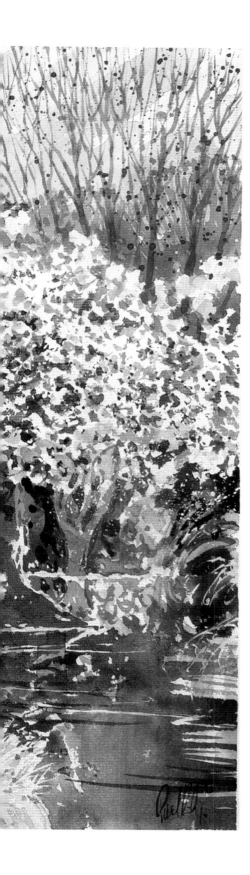

THE MAGIC OF WATERCOLOUR FLOWERS

Paul Riley

BATSFORD

Dedication
To our grandchildren, 'With flowers and sun.'

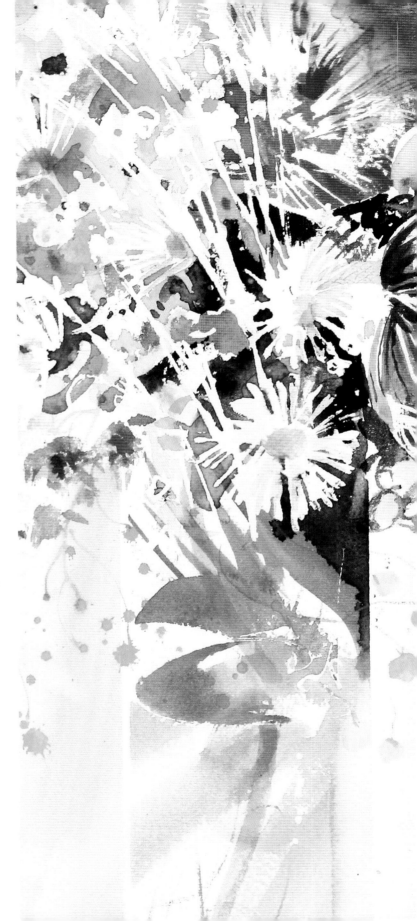

First published in the United Kingdom in 2015 by
Batsford
1 Gower Street
London WC1E 6HD
An imprint of Pavilion Books Company Ltd

ISBN: 9781849942812

A CIP catalogue record for this book is available from
the British Library.

20 19 18 17 16 15
10 9 8 7 6 5 4 3 2 1

Reproduction by COLOURDEPTH, UK
Printed and bound by 1010 Printing International Ltd, China

This book can be ordered direct from the publisher at the website:
www.pavilionbooks.com, or try your local bookshop.

Distributed in the United States and Canada by
Sterling Publishing Co., Inc.
1166 Avenue of the Americas, 17th floor, New York, NY 10036

THE MAGIC OF WATERCOLOUR FLOWERS

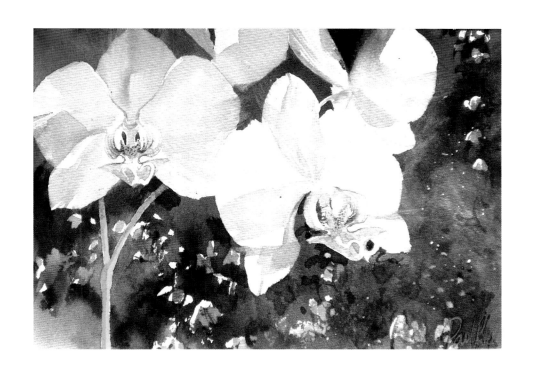

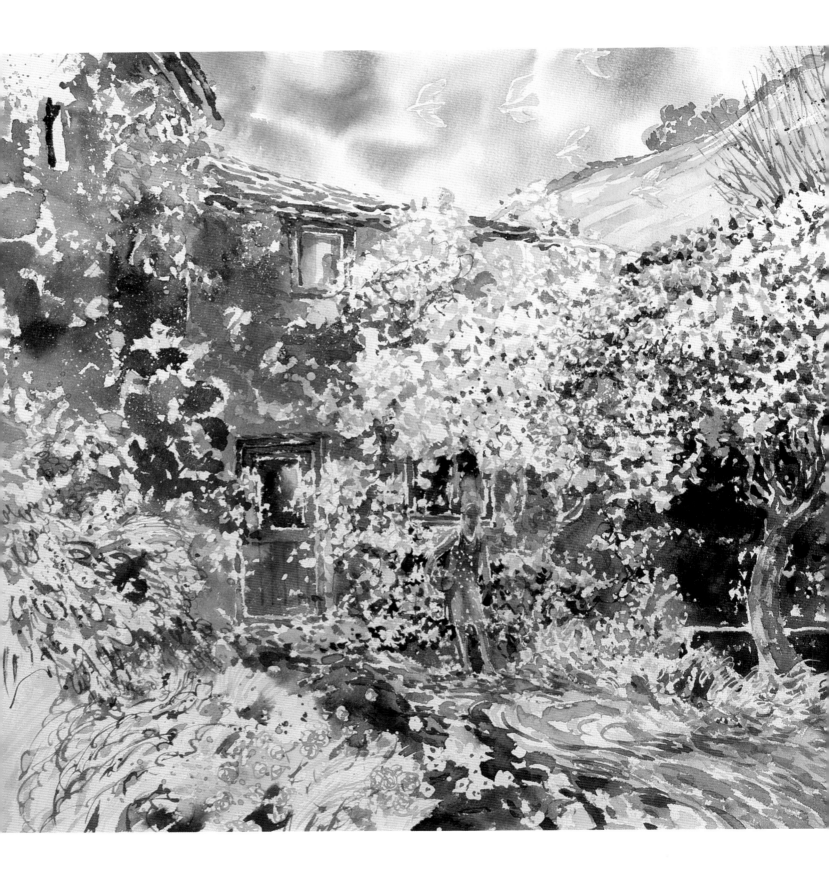

CONTENTS

INTRODUCTION

Seeing the title on the cover, some watercolour painters might well think, 'What, another flower book!' Fair enough, but I wanted to make this one very different. I wanted more oomph, passion and inspiration. And I wanted to express original thoughts, exploring the subconscious and stirring the imagination.

Looking at the contents list should give you a flavour of what to expect, not to mention taking a flick through the pages to see the explosions of colour – for vivid chromatics are the essence of flower painting, along with the magical world of wondrous abstract shapes. This is a multi-dimensional book touching on the many aspects of our world that flowers grace – not just gardens, parks and the greater landscape; they are part of our own mental landscape, for we nurture them, we present them as gifts, we enliven our homes with them and we visit famous gardens for the sheer pleasure of admiring them and enjoying their delicious fragrance.

However, if you want to paint flowers you cannot just rely on your familiarity with them. This is why I have put together a book that will not only inspire but also instruct in a way that is both accessible and stimulating for beginners and professionals alike. Some of the information will be a little simple for the experienced, but it is worth repeating. In other areas a more advanced approach is used to challenge all – not least myself! I start with a chapter on inspiration, looking at sources and methods. I then put the tools into your hands and give you advice on how to use them. We shall then explore the world of chromatics and light, observing carefully and evaluating. Finally, we shall use our imagination, which knows no bounds, and see where the study of flowers in all their wonder takes us.

Chicken in the Courtyard,
54 x 74cm (21 x 29in)
This image shows what is possible using a variety of tools and techniques. One's imagination is allowed to run rampant, veering towards the abstract at times.

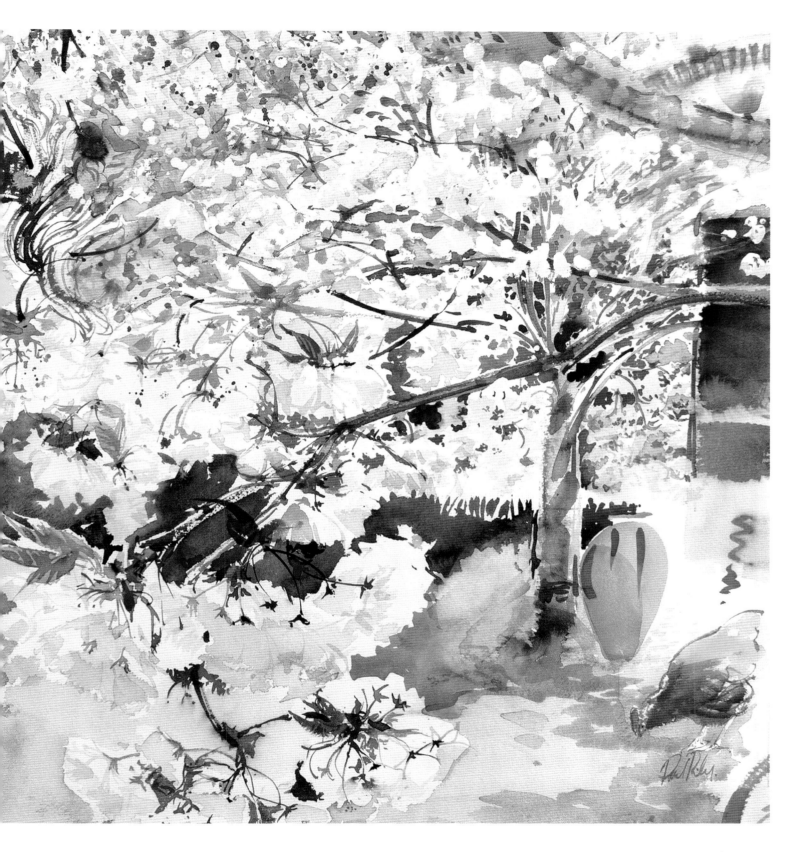

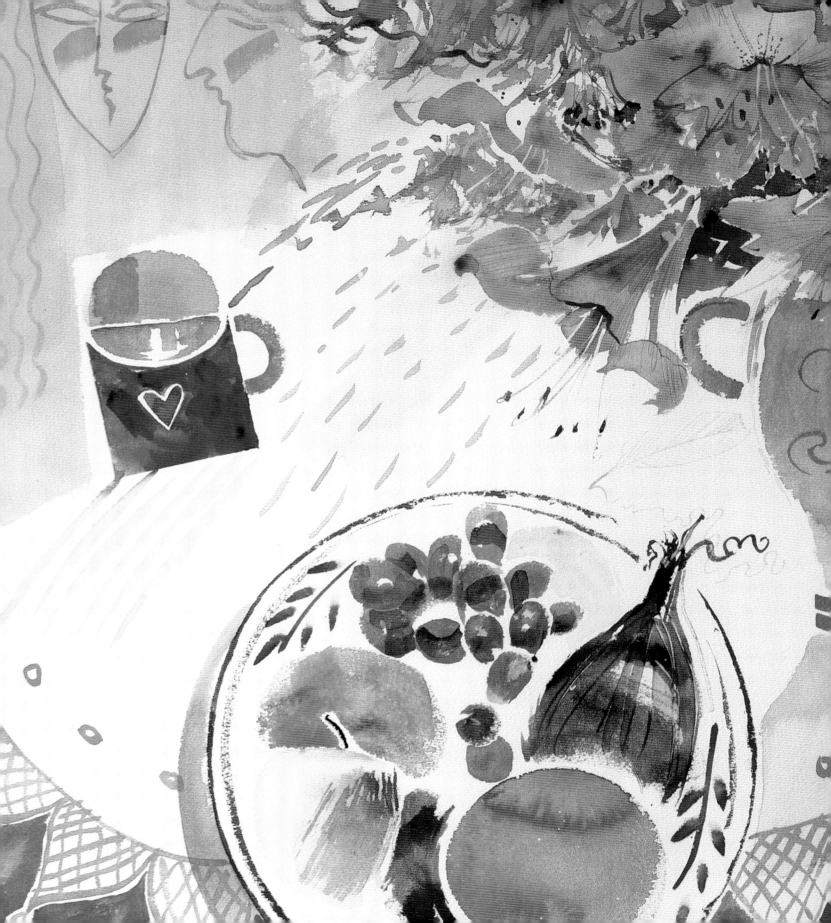

CHAPTER 1

INSPIRATION

What is that elusive ingredient that sets a painting on fire; that magic that beguiles the viewer? It comes from the inspiration of the artist. We artists need inspiration like lifeblood and seek it from numerous sources. In this chapter I shall give directions as to where I found my own inspiration and where you can look for yours. It will be derived from your subject matter, be it from family and home, the seasons, or a particular colour. We all have a natural affinity with a particular theme. It's how we relate to it that enables us to produce the images we do.

Azaleas and Red Onions,
51 x 70cm (20 x 27½in)
The idea is to transform the mundane into something more inspirational. In this case I have introduced a conversation with a 'love' cup of coffee.

Following the seasons

Inspiration is about how things move us. Like nature, it is an outside force that has the ability to affect the way we think and feel. As a species we react like any animal to the need to breathe, eat, drink and procreate. We are moved by birth, love and death. It's natural, and in the observation of flowers we are made conscious of the beauty and transience of life.

As a painter I am acutely aware of how the seasons affect the way I feel and see the world about me. I am lucky to live in the countryside, so I am very aware of the differences in character between spring, summer, autumn and winter. I can see the weather changing constantly, from swathes of rain to racing cloud shadows or brilliant blue sky. The earth where I live is particularly fertile, rich in iron that gives a beautiful red glow beneath the green of the grass. Wild flowers grow profusely and it is one of my special joys to see them arrive at their allotted time as the seasons progress.

Probably the most inspiring time is spring. We wait so long during the winter months for signs of fresh new growth that the first sight of spring flowers gladdens the heart. First come the snowdrops, often while there is still snow on the ground, then the hellebores (winter roses), rapidly followed by the joyous yellows of daffodils. By this time ideas are spinning out of me to try to capture this freshness.

Following hard on the heels of this bounty are the explosions of whites, violets and reds from magnolias, camellias and rhododendrons.

Daffodils and Primulas,
56 x 76cm (22 x 30in)
The cheery explosion of yellow daffodils in spring gladden the heart – hence the love cup and the chicken about to lay.

Then in rolls summer and the opportunity to really make the most of the world of flowers. If you are lucky enough to own a garden you have the opportunity to plant and nurture the blooms of your choice. If you don't, public gardens, florists and garden centres can give you just as much stimulation. I'm amazed at the choice of flowers, even in supermarkets, that enables us to produce the most flamboyant of still lifes using blooms such as roses, dahlias, fuschias and all manner of daisies.

Come the autumn things change rapidly; the fresh spring chlorophyll that greened everything is now going. The cells in leaves die and in their death produce remarkable browns, reds, oranges and yellows. However, flowers are still there to whet your appetite, including montbretia (crocosmia), calendula, and asters. At the beginning of winter you can still come across iris, begonias, witch hazel and cyclamen which will provide ample inspiration.

Throughout the year, the main sources of inspiration are greens with whites and yellows in spring; summer is a veritable kaleidoscope of primaries and secondaries; autumn is all reds and golds, while winter brings deep violets and reds. No wonder the seasons inspire painters and also poets and writers, who express the way in which flowers evoke love, pain, sorrow and joy. Reading poetry and prose gives the painter another view of the subject and invariably kicks off ideas for arrangements or ways of seeing.

When I am out walking I pick flowers and leaves and bring them back to study. I like to think I'm immortalizing them. They have such brief lives it seems only right that we as humans give something back to nature rather than just destroy.

Summer Bouquet with Pink Roses, 38 x 51cm (15 x 20in)
I like the fact that flowers have been the source for innumerable patterns. Here I have shown them move in shape from naturalistic to simple abstraction.

Autumn Leaf Study, 23 x 33cm (9 x 13in)
I collect leaves in autumn, noting the beautiful variety of reds and golds. Making studies of these is one of the great pleasures in life.

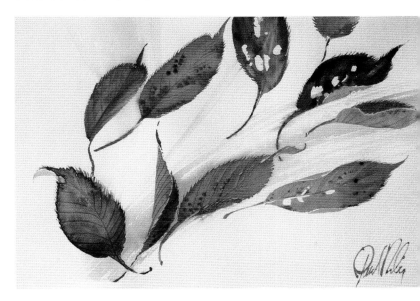

The qualities of white

I am sure the one thing I miss most when my eyes are shut is colour. It moves me in so many ways and reaches right down into my psyche to stimulate all kinds of responses. Later on (see page 46) I cover this amazing subject in more detail. Here I want to refer to just one very inspirational colour – white. You might say that's not a colour at all, but I say it's nearly every colour, as it picks up colour from all around. Shadows and reflections add a special inspirational quality that talks of what is not obviously there.

Pure white in watercolour is not painted – it's untouched paper. This means that you paint only what is not white. For example, if you wanted to paint a white daisy you would first paint the yellow centre then colour all around the petals, leaving the flower as reserved white paper. This is known as negative painting and requires an agile mind (see page 25).

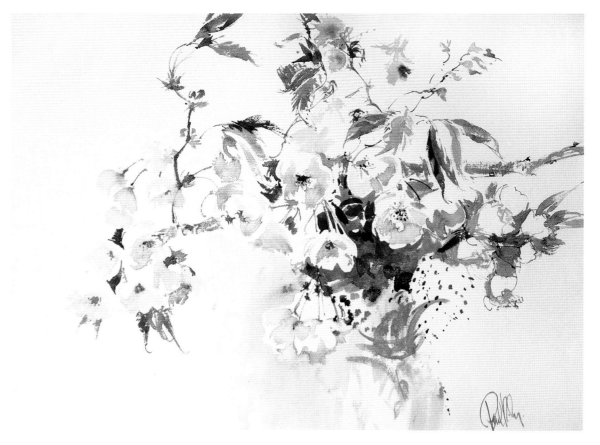

Study of Cherry Blossom, 51 x 70cm (20 x 27½in)
Springtime brings a plethora of white flowers, with cherry blossom among the first to appear. I place my easel right in amongst it and paint as spontaneously and quickly as possible.

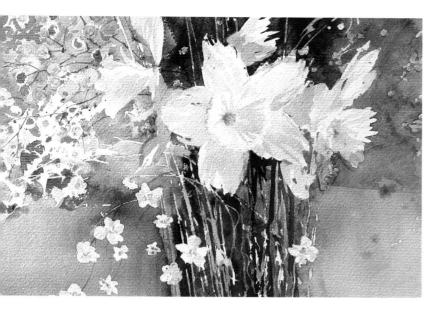

White Daffodils, 30 x 50cm (12 x 19½in)
In this painting I wanted the flowers to be especially white against a dark ground. To achieve this, I used masking fluid and once that was dry I applied a dark background wash. I then tinted the petals with a delicate series of transparent greys.

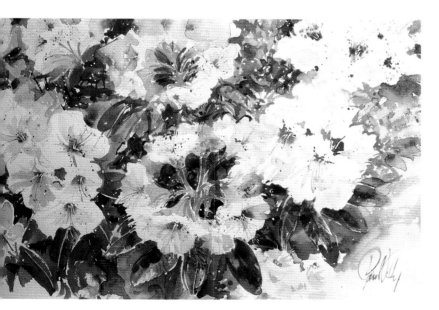

White Rhododendrons, 33 x 51cm (13 x 20in)
White rhododendrons are fiendishly difficult to paint: firstly the shape of the basic floret then the assembly, all to be done by negative painting including stems and leaves.

I particularly like painting white flowers for the challenges they present. There is an extra frisson when there are many flowers overlapping one another and acute observation is needed to see which petal is darker or lighter than the one behind. It is this concentrated looking that exercises the mind like no other subject matter in any other medium. Challenge can be equated with inspiration – if you choose subjects that stretch and question your capabilities you will open a door to new possibilities.

Flowers are available in all colours, so at any given time you should be able to choose one particular colour that expressly moves you. Each one has its own story waiting to be told. Using the visual medium of watercolour can make the story especially vibrant. I choose white because it has that clean purity that expresses hope, most of all in the emergence of cherry blossom in spring – no wonder the flowers are so cherished and venerated. They herald the notion of rebirth.

Close to my home is a very large and beautiful garden with a riverfront location which is a major source of inspiration to me. There are numerous established trees and shrubs that burst into leaf and flower once spring kicks in. The first giant to announce its presence is a *Magnolia grandiflora* (see page 112). This magnificent display is rapidly followed by the bright detonations of the reds and whites of camellias. It is important to strike while the weather is fine as March and April can be capricious, bringing in high winds, rain and sleet which hammer the large blossoms.

The essence of painting

What inspires one to paint in the first place? As a child one doesn't need much encouragement – it seems to come almost as naturally as breathing. Then comes writing and it all seems to change. The magic of reading takes over, and the magic of painting diminishes. In my case I embraced both with a passion, probably because I lived in an artistic household and was encouraged on all fronts.

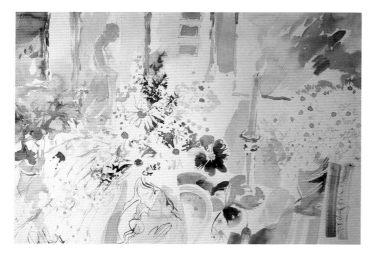

Fragments, 51 x 70cm (20 x 27½in)

Fragments is a bit like a personal collection, holding cherished memories. Each element is an abstract reduction distilling the pleasures it evokes.

When I decided to take painting seriously my father set about giving me a solid grounding in drawing. It was from this discipline that I learnt how various were the forms, textures and colours of the objects in our lives, none more so than in flowers. In studying them, I needed to understand how they grow. A big straggly dahlia was a complete mystery to me until my father pointed out its spiral growth pattern that extended outwards to the extremity of the flower head. Drawing with this subconscious understanding seemed like magic to me. With an increased awareness of the botanical world around me I am fascinated to see flowers in different contexts. I constantly look for places and circumstances where flowers flourish and enhance their surroundings.

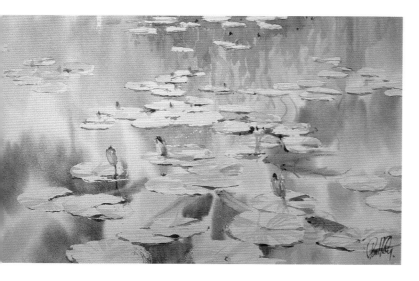

Goldfish in the Lily Pond, 28 x 48cm (11 x 19in)

To create the effect of fish submerged in water required a specific approach. I used a sponge dipped in shades of red and orange and wiped the fish shapes into the sky-coloured water (remember that still water is reflective, so look up and paint the sky).

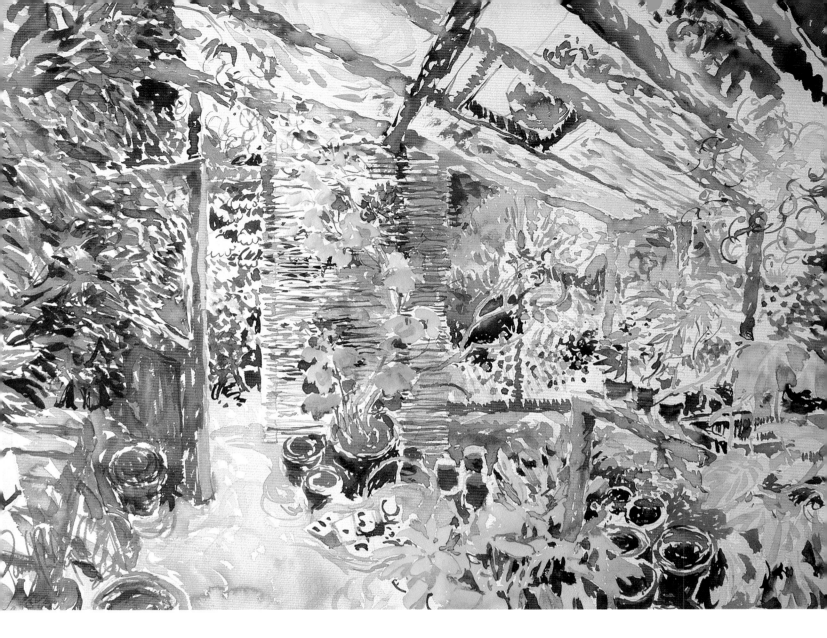

In the following chapters I shall look at flowers with people, in water, in the landscape and in the garden. In each case the flowers will tend to dominate. Why? I believe it's because they have attitude. Though they are fixed in the soil they can waft in the wind, glowing with colour, attracting insects and wooing us with their scent. Their power to command our absolute attention and respect is out of proportion to their size.

Mimi's Greenhouse,
56 x 76cm (22 x 30in)

The greenhouse is a myriad series of small shapes and colours needing a special technique. I used a 'van Gogh' method of rhythmic touches involving predominantly the complementary varieties of red and green (see page 51).

Abstraction

In one's initial development as an artist, the aim is to make the subject look like that which it represents – that is to say, to make a flower specific and detailed like a photograph. This takes skill and practice, and many of us are well pleased with this capability once achieved. However, some of us feel there must be more, and that is when we come to the stage where we want to abstract the subject, looking for less to make more and to get to the essence of what we portray.

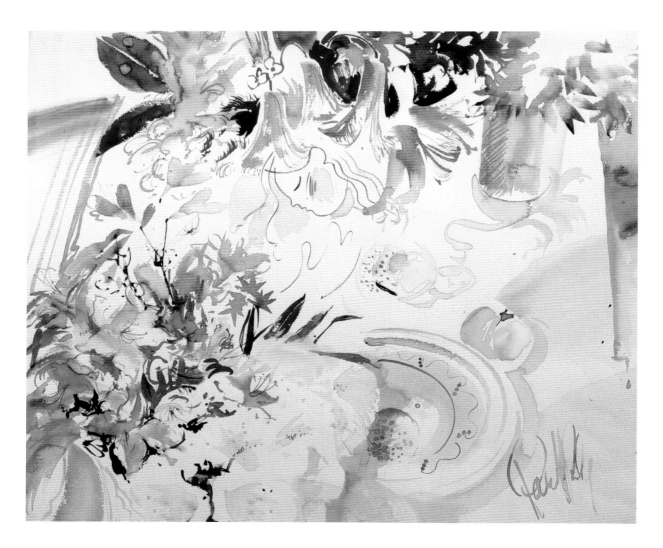

Springtime, 56 x 66cm (22 x 26in)
Many shapes have been reduced to a childlike simplicity. The idea is to go for the essence rather than the detail.

The process of abstraction is that of subtracting inessentials, such as suggesting a tree by its shape rather than painting all its leaves and branches. Most painting is what we might term figurative with various degrees of abstraction. When taken to the ultimate it becomes totally non-figurative, reduced to signs, gestures and geometry, such as in the work of Jackson Pollock and Mondrian.

One of the themes I explore in my painting is the tension between the naturalism of the real world of plants and flowers and the patterned representation that they are reduced to in fabrics and ceramics. In our primitive development we had the urge to depict the real world around us with symbols and signs that, in their way, were refined distillations of immense power. Flowers were particularly suited to these simple representations and were therefore used by people all over the world to indicate diverse religious and secular meanings. Researching these various images gives us the opportunity to enrich our paintings further.

As you can see, inspiration comes from many sources, and which of them hold special interest is a matter of personal taste. Whatever the source, searching and looking makes the whole process of painting the special joy that it is.

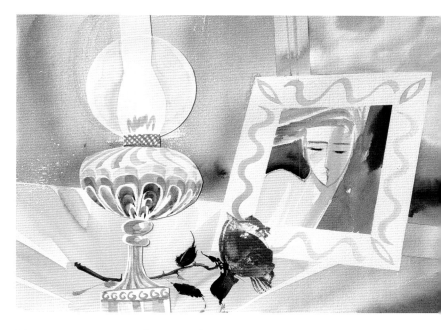

Memories, 30 x 51cm (12 x 20in)
Here I have abstracted the image by reducing nearly everything to crisp, hard-edged shapes. The contrast is the naturalistic rose, linking the lamp to the picture.

Tulips and Fruit, 39 x 44cm (15½ x 17½in)
The strength of this image relies on the aerial 'plan' view (see page 37). Most of the objects have been reduced to simple blocks and interlinked circles of different sizes, while the flowers have been formalized in the manner of a child's drawing.

CHAPTER 2

TIPS AND TOOLS

Watercolour painting demands a greater mastery of its tools than any other medium, so the quality of the brushes, paper and paints we use is important if we want to make the most of our ideas. In this chapter I shall explain how to select and manipulate each tool. There are exclusive techniques to watercolour which I shall demystify, with demonstrations to show what can be achieved with simple means. Understanding your tools and their uses will release the potential of your creative mind, for you will paint with greater freedom if you are at ease with the means of getting colour on to your paper.

Essential equipment
I love to surround myself with the clutter of my trade. I have a large variety of tools and brushes – all good friends that give great pleasure and joy when used.

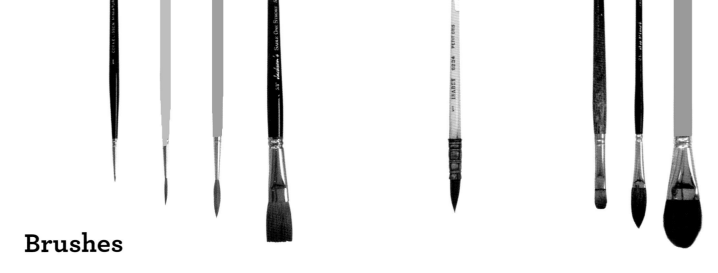

Brushes

▲ **Sable** The most versatile and useful of all the brushes are those made of sable, which have a firm, springy touch. If made well, they have a very fine point. The best sable is Kolinsky, though these brushes are very expensive. Sable brushes come in various shapes including (from left): small spotters for miniature work; standard round, which comes in sizes from 0 (small) to 16 (large); riggers for fine lines; and flat.

▲ **Squirrel** Squirrel hair is soft and produces lush shapes especially suited to flower petal and leaf painting. Round squirrel brushes range in size from 0.3 to 10.

▲ **Filbert** Filberts are flat brushes with either pointed or round tops, again good for petal and leaf shapes. These come in sable, pony and squirrel.

**Study of Wild Flowers,
23 x 33cm (9 x 13in)**

A painting such as this demands many types of brush to execute the variety of strokes required. First I used a No. 3 round sable to draw in the basic shapes in a pale colour, removing any mistakes with a soft, damp natural sponge. Small, light-coloured flowers were masked with masking fluid (see page 28) applied with a small sable round brush, with soap put into the bristles first to protect them. For all the various flower and leaf shapes I used squirrel hair flats, a traceur and a selection of oriental brushes. Much of the underwashing and overwashing was achieved using a hake. Shadows were added using a filbert.

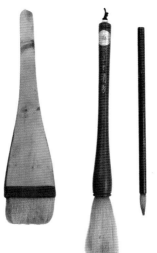

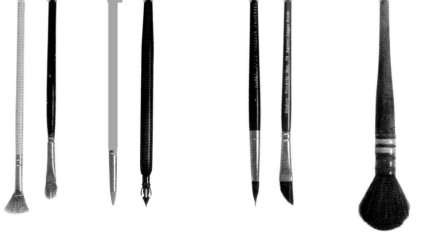

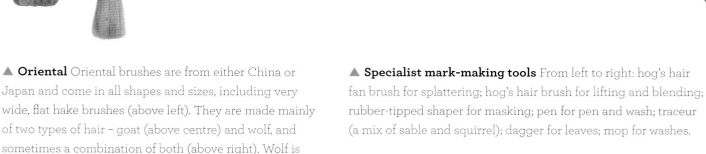

▲ **Oriental** Oriental brushes are from either China or Japan and come in all shapes and sizes, including very wide, flat hake brushes (above left). They are made mainly of two types of hair – goat (above centre) and wolf, and sometimes a combination of both (above right). Wolf is springy, goat is soft.

▲ **Specialist mark-making tools** From left to right: hog's hair fan brush for splattering; hog's hair brush for lifting and blending; rubber-tipped shaper for masking; pen for pen and wash; traceur (a mix of sable and squirrel); dagger for leaves; mop for washes.

Palettes

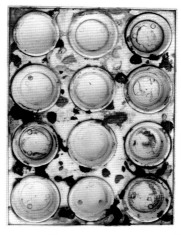 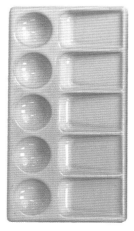

I generally favour palettes with deep pans, allowing for plenty of colour for washes. Here is one reminiscent of a muffin tray. I use the small porcelain palette when I need only small amounts of colour.

Extra tools

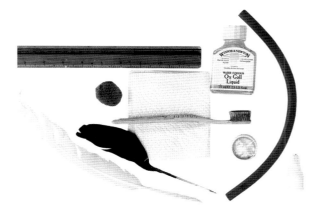

Here are some other tools you will find useful: a triangular rule for straight lines; flexi curve for bent lines; ox gall, a wetting agent to improve the flow of the paint; soft blending sponge; toothbrush to splatter paint for texture; quills for drawing in watercolour; rag for ragging textures; salt, to give texture; tissue for blotting.

The way of the brush

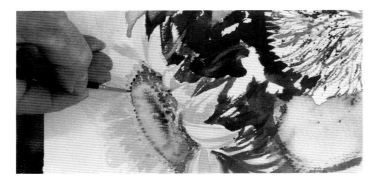

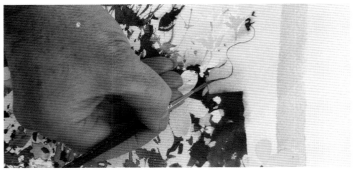

Spotter Primarily a miniaturist's brush, a spotter is very fine. I use it for indicating small marks such as anthers, stamens and delicate marking on petals and leaves.

Rigger A rigger is a sable round with particularly long hair, used here to indicate fine lines typical of certain stems, stalks and filigree elements.

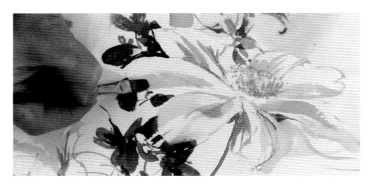

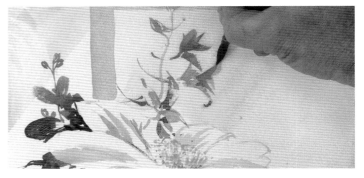

Flat A flat brush is used to produce ribbon-type strokes and to cut into sharp edges. It is shown here adding crisp, pale tones to a petal.

Squirrel A squirrel is an ideal brush to 'print' leaf and petal shapes. I use different sizes for each change of flower size.

Hake Made of goat hair, a hake is a very soft, large flat brush. I use this for underwashes and overwashes. Used on edge, it creates interesting textures.

Traceur A traceur is an intriguing brush that comes to a super-fine point, which enables all kinds of strokes, achieved by manipulating the tip and body alternately.

Two-colour round For when petal colour bleeds from one colour to another. Two colours, one for the tip, the other on the body can be executed with one stroke.

For a rainbow stroke, two or more colours can be painted along the tip of a hake brush and applied in one go.

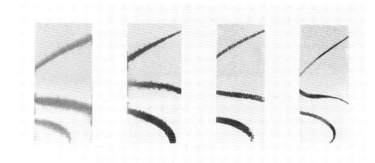

It is difficult to determine how much colour will bleed when the paper or a previous wash is damp. A simple exercise timing the drying from left to right will familiarize you with the stages; on the left very damp, on the right very dry. Soft, damp strokes will aid in blending and adding depth.

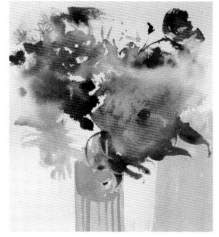

Soft-focus Rose, 23 x 33cm (9 x 13in) This image gains from the information learnt from the drying times. The blues, violets and reds are applied first on wet paper. Then add greens on to a slightly damp paper and finally the dry touches; the vase and rose centre.

Pointillist Bouquet, 14 x 23cm (5½ x 9in)
In flower paintings there is often a highly textured area where there are multiple small flowers, stalks and leaves. For this, you need to develop a rhythmic flickering stroke, using a small squirrel brush. The trick is to keep the colours separate and thus clean. Different-shaped strokes will produce individual types of flowers and leaves.

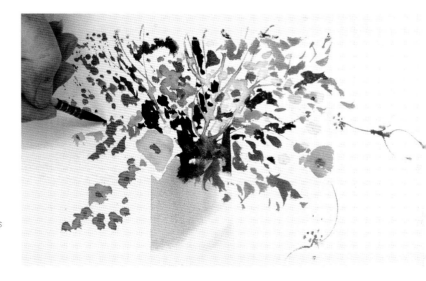

White-line painting

The biggest problem for most beginners in watercolour is avoiding muddiness. This occurs when two or more colours merge with one another, creating unwanted tertiary colours (see page 52). This is disastrous when flower painting and is especially noticeable when the green of leaves is allowed to drain into red, violet or yellow flowers.

The usual way to avoid this happening is to wait for the colours to dry, but this is very time-consuming and can make you lose impetus. The best solution is to isolate the colours by leaving a dry white line between each zone. This can be thin or broad and can be expressive in itself. Once the painting is dry, you can overpaint the white zones or leave them white, depending on the effect you want. Not only is this technique useful for keeping colours clean, it helps to reinforce form and can also be used to create the effect of light creeping around the edge of a form.

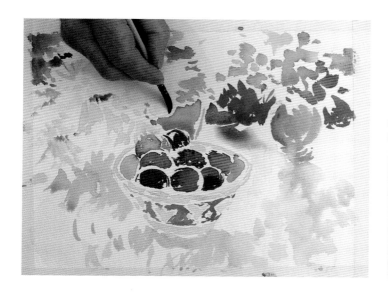

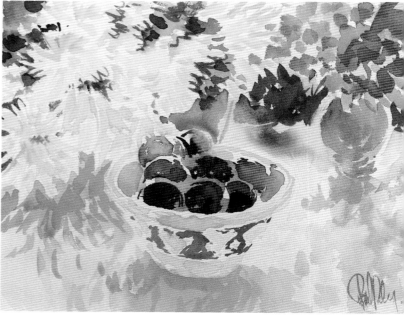

I have kept this image relatively simple in order to show the basics of white-line painting. The colours are very strong in contrast; if they were to bleed the result would be very messy. I therefore left a generous space between each colour, varying the width to add interest. This method implies a suffusion of light surrounding the objects.

Chrysanthemums and Plums, 23 x 30cm (9 x 12in)
Once the paint had thoroughly dried I could make adjustments, overpainting, adding detail, softening colours and balancing the tones. I used a dilute plum colour, violet and blue to tint some of the white line surrounding the plums. I then added details to the chrysanthemums and softened the jug to the right.

Negative painting

People who come from using opaque mediums such as oils, pastels and acrylics find that when attempting watercolour painting, they hit a brick wall when they try to paint white.

Although you can buy white watercolour pigment in a tube and there are some demonstrations in this book incorporating white (as on pages 42 and 66), the pure way to paint white objects is not to paint them at all; you paint that which surrounds them, or the shadows within them that give them form. This means you have to plan ahead. For very complex images, I will very lightly draw with a pale blue or grey broken line then paint the in-between bits that have colour. In some instances I just paint with shadow, leaving the viewer's imagination to fill in the outline.

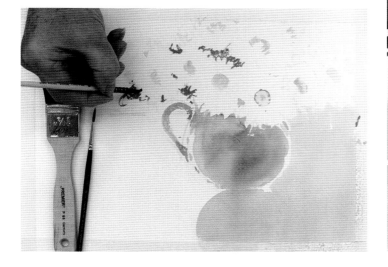

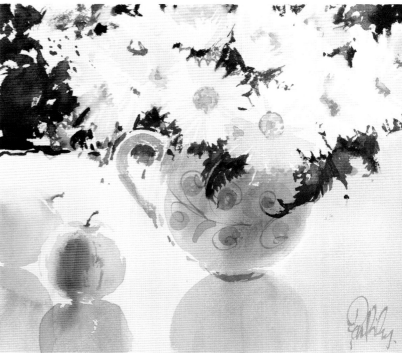

I have commenced by using a white line for the right side of the composition. To do this, I blocked in the jug and its shadow, using the large flat brush seen here under my hand. Then I added the shadow to the table. I began the flowers by painting in their yellow-green centres, which varied in shape from circular to elliptic. I then started on the leaves.

White Daisies, 23 x 27cm (9 x 10½in)
The light around the jug gives the effect of *contre-jour* lighting (see page 64). The leaves are fully developed, revealing the cluster of daisies. Some of the daisies are grouped together and not surrounded by dark leaves. I let the shadows give the visual clues. I use the same broken-light effect around the apples.

Making studies

Small studies are essential for getting to know a particular flower. I use them often to explore new techniques, too. My method for starting these investigations is to do an in-depth drawing first, noting the salient points that characterize the flower.

Here a poppy had a noticeable pleated texture that needed a rather special approach. I mixed an intense amount of red and dipped the edge of a folded card in it, then simply printed it on to the paper to replicate parallel straight and curved lines.

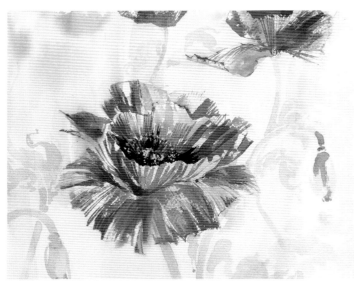

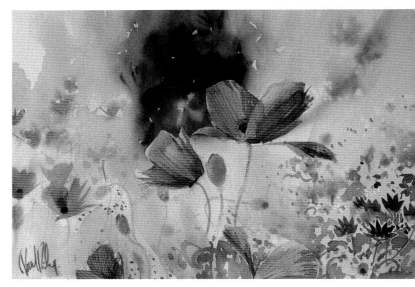

Poppies, 23 x 27cm (9 x 10½in)
All the printed marks give the petals a striated surface that adds to the fragile look of the flowers. This is typical of the giant poppy (*Papaver orientale*), a wonderfully dramatic flower that looks positively carnivorous. Once the texture was dry I lightly tinted the petals in some parts to pull the flower together and added the details. The stamen are picked out using a sharp scalpel blade.

Poppies Study 2, 23 x 33cm (9 x 13in)
In this study of *Papaver commutatum* I have used some of the techniques explored above. The difficulty is in not letting this flower look like a brick – it's important to give the effect of transparency. Here I have contrasted the light half of the flower against a dark ground with a dark section against a light ground. This, together with striations scratched into the wet petals, aids the illusion.

Anemones with White Rose, 23 x 30cm (9 x 12in)

I am always exploring new ways of portraying roses, which are steeped in historic symbolism both religious and secular. There are many varieties, each one needing its own interpretation. In this image I have shown a simple tea rose just opening from a bud, accompanied by other summer flowers placed in an imaginary vase.

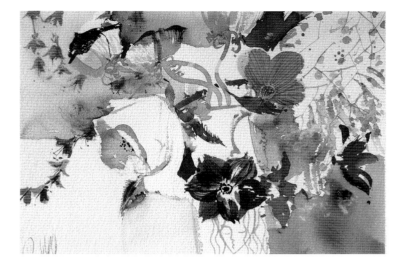

Study of White Roses, 23 x 33cm (9 x 13in)

I love the work of oriental painters and like to think that I am performing a kind of fusion painting between East and West. Rather like fusion cuisine, one has to get the flavours just right. Here I have used a typical oriental composition with the peace rose (*Rosa* 'Madame A. Meilland') trapped in a tangle of foliage, glass, reflection and shadows. I chose oriental brushes to paint its dynamic forms.

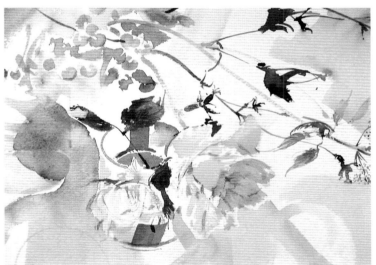

Rose Study with Irises, 23 x 33cm (9 x 13in)

All the paintings in this book featuring roses have benefited from the studies I made looking at colour, tone and texture. The most difficult roses to paint are the multi-petalled kind, particularly a ragged-edged variety such as 'Penelope'. Its creamy white colour only adds to the challenge. The problem was to keep the brushwork fresh, which necessitated clean, brisk strokes. I have used strong contrasts with especially deep-toned colours.

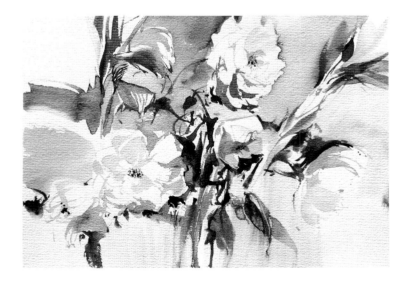

Masking fluid

There are occasions when reserving white paper using traditional negative painting can prove too fiddly. This is when a removable latex masking fluid is invaluable. It is available coloured for easy identification or colourless – the latter is the one to use if it will be difficult to remove.

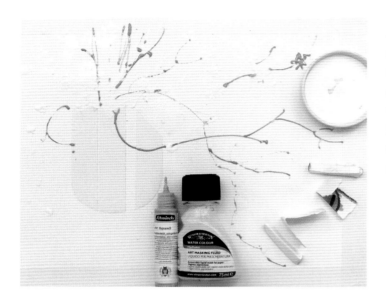

A jar of wild flowers calls for myriad small touches and fine lines representing flowers and stalks. This kind of image is eminently suited to the use of masking fluid. Here you can see the fluid and tools used in this picture: a dish for dipping in; a dispenser which has a needlepoint for drawing lines, dots and complex flowers; bits of folded paper, used with a twisting action for applying fluid in larger areas; and, for the bigger flowers, some paper rolled into round shapes.

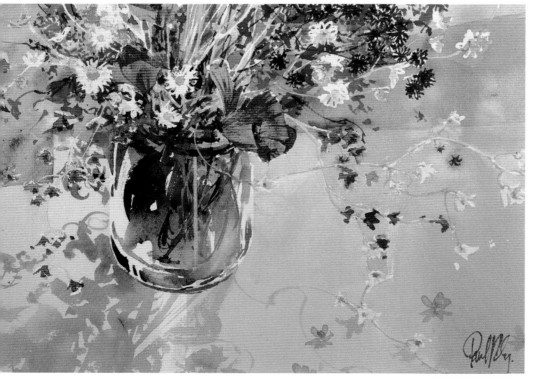

**Poppies in a Jam Jar,
23 x 33cm (9 x 13in)**

When using masking fluid in a painting like this, the tendency is to be too sparing with it. I maintain you should put on as much as you think you need, then double up then add as much again! Be assured the final result is worth it. Make sure you take stalks and flowers outside the image to generate a luxuriant feel that cannot be contained on the paper. When everything is dry, add background tones and splatter colour overall. Once the painting is dry again, remove the masking fluid with your finger or an eraser and add further detail to the flowers and jar.

Masking tape

There will be occasions when you may want to mask out large areas that would be rather wasteful on masking fluid. For these, I use masking tape. You will need a low-tack tape that won't spoil the surface of the paper and a few basic tools.

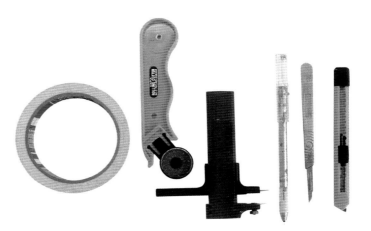

Masking tools (above): From left to right, masking tape; rotary cutter for long curved and straight lines; compass cutter for discs, circles and so on; swivel blade for small irregular shapes; two types of scalpel, the first for studio use, the other retractable for safety and for use outdoors.

I began by making a small sketch to help me determine the layout of masking tape for a painting of roses (shown below), then I drew out the shapes on the tape with a pencil and cut them out. I masked the flowers first, cutting out separate petals and then assembling the whole blooms. I then masked a background rectangle for the dark tones – masking tape is ideal for crisp, straight edges. Finally, I laid down two strips to mask the outside of the glass.

Rose with Attitude, 23 x 33cm (9 x 13in)
Using masking tape gives crisp, highly defined edges. This adds drama and strong contrasts to attract the eye. Soft edges can be added later using a damp sponge.

Painting glass

The question I am most often asked is probably how to paint glass. The simple answer is to just paint what you see, not what you think glass ought to look like. It is a crisp, hard-edged material, both reflective and see-through, so look for reflections and also what is behind it.

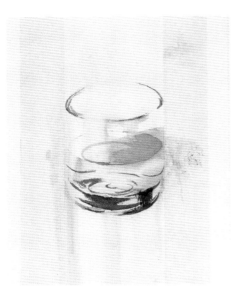

STAGE 1
I put down two strips of tape to give a crisp edge to the glass then painted exactly what I saw, using mixes of black, indigo and perylene green.

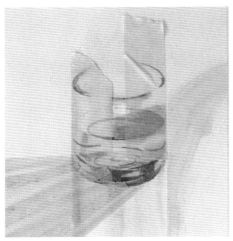

STAGE 2
For this stage the paint and paper needs to be totally dry. I made fresh strips of tape even more low-tack by sticking and unsticking them to my clothes, then masked off the inside of the glass with a 1mm overlap. I also masked the shadows radiating from the glass. Next, I painted in the shadows, reflections and radiating shapes. I often use a soft natural sponge to add these tones, blending and wiping until I am satisfied.

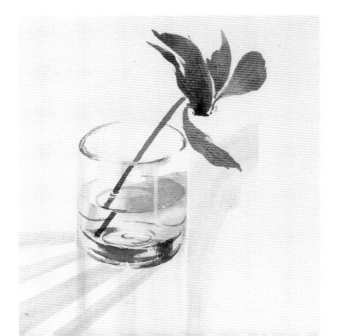

FINAL STAGE: Cyclamen in a Glass, 18 x 14cm (7 x 5½in)
When I put the flower in the glass, several things became immediately apparent. First, as it passed in front of the back rim of the glass it was solid; as it passed behind the front rim it was obscure and therefore broken. Then, as it hit the water, it reflected rings and changed to a lighter tone. As it went deeper that amazing physical phenomenon occurred where the stalk was refracted, appearing disjointed by the water surface. Painting glass does wonders for one's powers of observation.

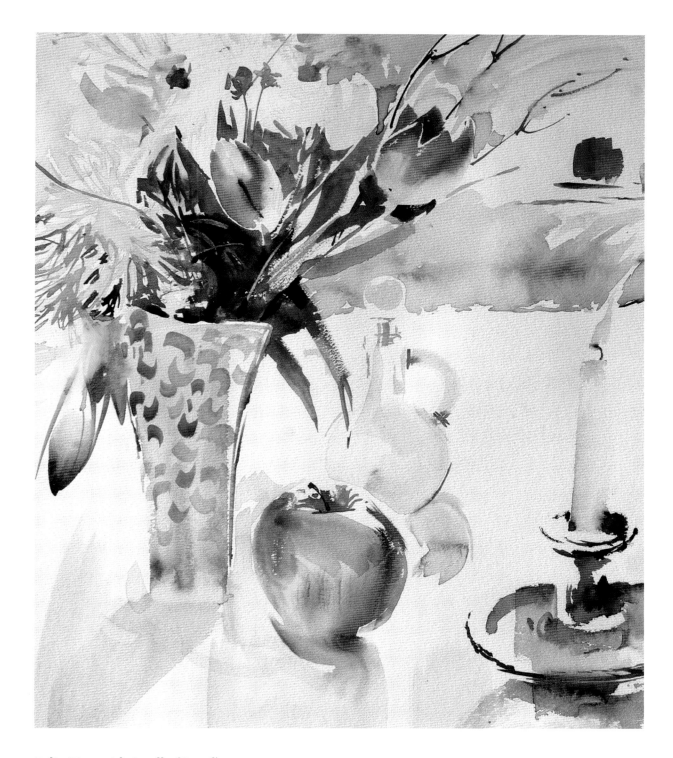

Tulip Time with Candle (Detail)

The surprising thing with painting glass is how little definition is required to do so. The small oil dispenser in the background was merely suggested using delicate greens, greys and violet tones.

CHAPTER 3

COMPOSITION

Flowers can be an unruly bunch and usually need organizing to form a decent image. This is the business of composition, meaning the design of the overall picture. The purpose of this process is to lead the viewer's eye towards that which attracts you as an artist. Like a music composer with the notes provided by different instruments, we use our colours, shapes and textures to excite the viewers and draw them to the crescendo that is our point of interest.

White Rose with Wild Flowers,
56 x 76cm (22 x 30in)
Composing flowers in a painting is like a dance in which you lead your partner around a garden of vivid colours, weaving a pattern of gaiety.

Creating balance

Balancing is something we normally associate with our ears in order to stay upright. However, our eyes also seek balance – they are attracted to high colour and tonal contrast and less to soft contrasts. This means that in order for the painting to attract the viewer's attention and circulate it about the image; balance is essential.

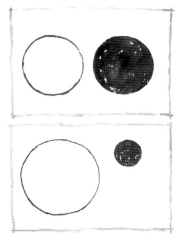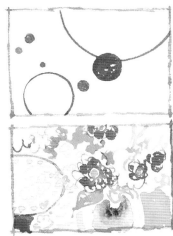

Dark, hard-edged objects attract and therefore outweigh light objects (top left). A balance is achieved by reducing the dark and enlarging the lighter object (bottom left). A balancing act can be created between several large and small objects which overlap and even stray outside the picture plane (top right). The principle in practice (bottom right).

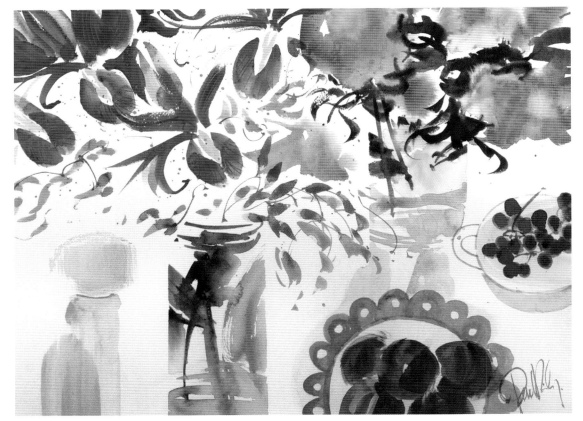

Blue Irises and Plums, 41 x 51cm (16 x 20in)
The balancing act in this painting involves several elements. Firstly the big shapes of the vases, bowls, dishes, flowers and fruit. Some are dark, others lighter. Next the tones and then colours. Their distribution keeps the viewer's eye moving.

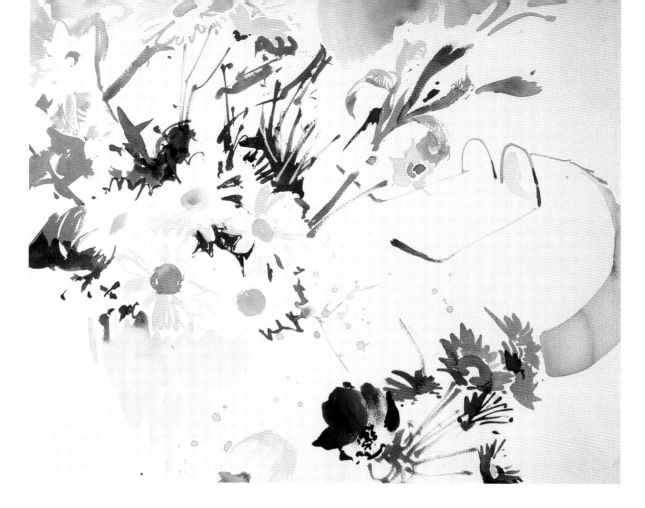

The orchestration of a painting is a complex process. A book or a piece of music is experienced over a period of time; it evolves, expanding and contracting in pace as you read or listen. The whole of a painting, however, can be seen at a glance and judgement is made – yet it is possible to inject a timeless quality into a painting that has people trying to read it forever.

A painting such as this has depth – depth of meaning and also an abstract depth. It is the latter that requires the balance of colours, tones and textures to be in a form of harmony not dissimilar to the way in which music composers create their sounds. Dark tones and deep colours such as reds and blues attract the eye and therefore need to be distributed throughout the image, counterbalancing the paler colours and tones. Textures come from variety in marks. These alter in tone and complexity and need to be counterbalanced accordingly.

Quite often, during the process of making a painting, all the detail and weight occurs towards the bottom of the picture, putting it out of balance. It is always worth turning a painting upside down to take a fresh look at the composition, then counterbalancing it accordingly.

Study of Flowers without Glasses, 41 x 51cm (16 x 20in)

The title of this picture is ironic in that I painted it without my glasses. What I have done here is to effect a balance between the circular objects in various tones, be they flowers, the glasses or simple swipes of tone.

Compositional choices

The images shown right demonstrate how I use thumbnail sketches in colour to explore ideas. One of the first questions to ask in any composition is 'what am I trying to achieve?' In this instance I am searching for an alternative to the basic concept of a still life. I have looked at the idea of involving a landscape – not necessarily an original concept but one certainly worth considering.

When designing an image it sometimes becomes necessary to simplify; to go for the essence. Deciding what to leave out and what to put in is the essential first move in any design. Next comes selecting the right brushes to do the job, giving vigour and intensity to the work.

The top sketch is a very rapid series of colours and tones used to establish the basics of the composition – no detail is required, just the spirit of the idea. The bottom sketch is doing the same thing, exploring the inside/outside idea with the opportunity to add flowers or still life to a specific landscape, whether real or purely imagined.

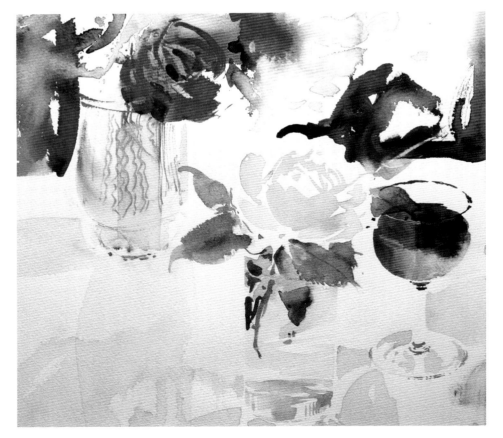

Roses with Wine, 30 x 30cm (12 x 12in)
Here I have made a play between the depth of tone in the red rose and glass of wine and the contrast with the white rose.

Elevation and plan views

Two basic ways of looking at flowers, either as a study in themselves or in a still life, are as elevation and plan views. Think in terms of architecture: the plan view shows the subject from above while the elevation shows it from the front, side or even from below.

For still-life objects, the elevation view is best with rectangular and cylindrical vessels. Bowls look awkward with fruit popping over the rim like strange heads in a boat, so for depicting fruit in dishes and bowls I prefer the plan view. The beauty of this view is that you are playing with circular shapes, from the flowers to vases, bowls, dishes and fruit — including, in many instances, coffee-cup and wineglass stains.

The two sketches above show how a change of viewpoint can radically alter a painting's potential. The 'elevation view' at the top is ideal for experiments in *contre jour* and shadow patterns. Below, the 'plan view' emphasizes cyclic shapes and introduces the opportunity to show decoration in bowls.

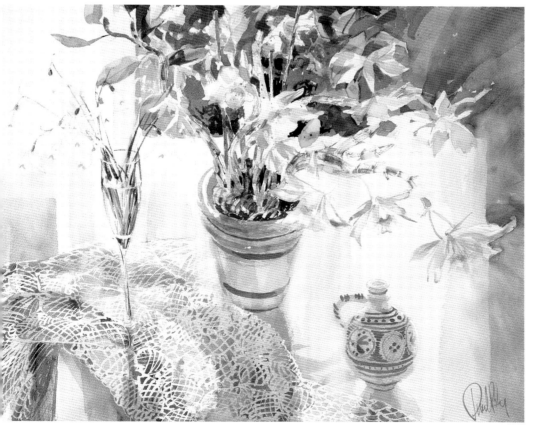

White Orchid with Snowdrops,
51 x 70cm (20 x 27½in)
In this 'elevation view' I have made use of the back lighting to give long shadows. This emphasizes the verticals to contrast them strongly with the free-flowing forms of the orchid.

Symmetry and proportion

As can be seen from the size of many of the images in this book, I like to work on a large scale. One of the main reasons for this is so that I can reproduce the flowers near life-size or even bigger. However, most of my images start from a thumbnail sketch.

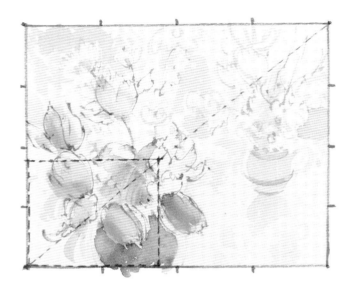

To scale them up in proportion, I lay the thumbnail in the bottom left-hand corner of a larger sheet (shown here by the dotted lines). I then strike a diagonal through the two corners as shown. Any point on the continuing diagonal will produce a shape the same proportion as the sketch. The small sketch is then divided into four quarters as shown right. The same is done to the larger image and it is then a simple matter of using the marks to scale up the elements in the sketch. I don't use a pencil on watercolour paper – a No. 2 round sable and pale pthalo blue is ideal. Any mistakes can be sponged off with clean water.

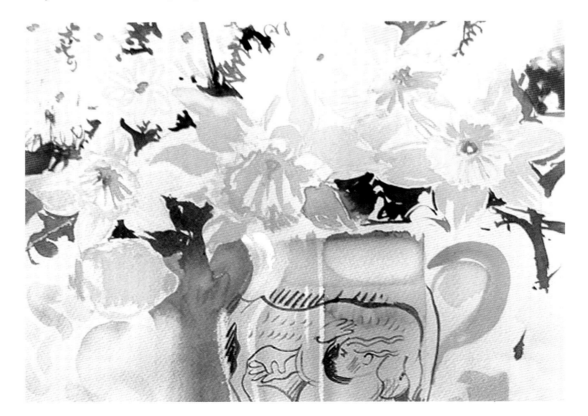

Daffodils in Goat Jug, 23 x 33cm (9 x 13in)
This image was done from a small sketch. Even after scaling up, I have managed to retain all the freshness of the original concept.

Understanding your subjects

Any good gardener will know that successful planting relies on a harmonious relationship between the flowers and the gardener too. So it is with the composition of a painting – for success, it necessitates an understanding of how flowers behave.

While composing may seem a question of a simple ABC of layout options, more is required to obtain greater meaning in a painting. One must empathise with the subject. In the case of flowers, understanding their variations in character from bud to death will assist the compositional process by adding depth of meaning. In this way one adds more interest and intrigue than just the sum total of the compositional elements.

Rose Garden,
22 x 32cm (8½ x 12½in)
This is a wonderfully overgrown rose that dominates its space, leaving just a glimpse of the 'civilized' garden beyond.

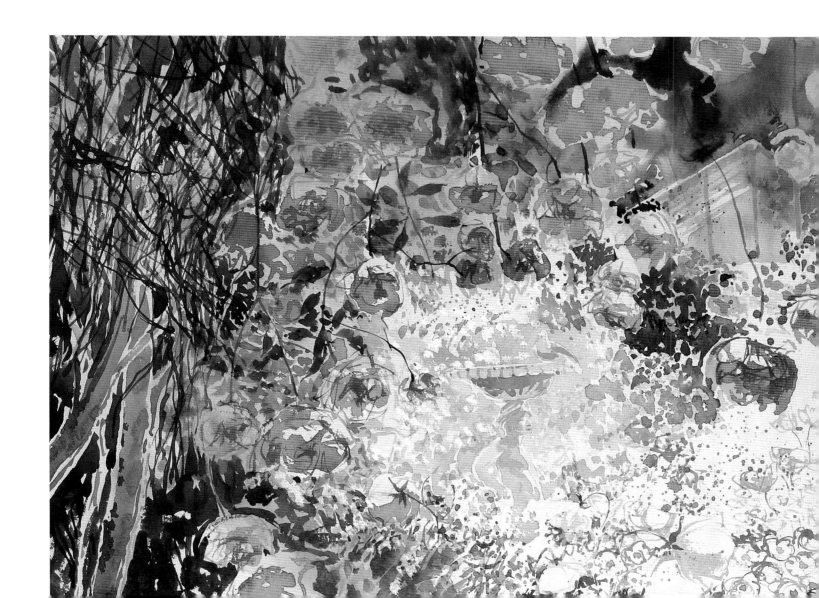

The centre of interest

It is the artist's job to take the viewer on a walk through their painting – lead them along the garden path, as it were. Where are we taking them? To what delights and sensations? The painting must have a centre of interest that the work is all about, whether that is a flower, an object, or a group of flowers.

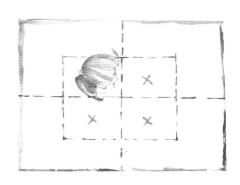

As humans we have binocular vision, and to examine an object or scene we look directly at it, placing it in our centre of vision. Translating that to a painting, though, does not usually give the best result as the symmetry of the design lacks interest. If you place the object off-centre, other compositional possibilities occur.

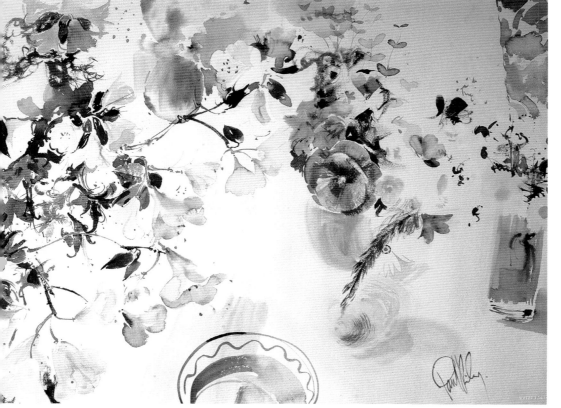

Above I have shown a central zone, indicating possible placings to choose. In particular, I have placed flowers in specific locations. This does not demonstrate a hard-and-fast rule, however. Every flower has a 'face' and the direction it is looking at can determine its location in the image.

Spring Flowers with Lemons, 56 x 76cm (22 x 30in)
The centre of interest here is quite obviously the poppy. The colour contrast, edge definition and its location say so. All the other flowers beat a trail to its door while it gazes into the painting.

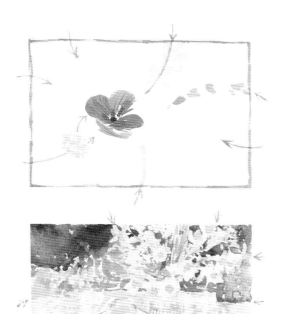

Once a location for the centre of interest has been chosen, the 'garden path walking' can commence. The outside edges of the painting form what is called the picture plane. The entire composition is enclosed in this. However, this picture plane is not a shopping basket with all the produce contained therein – it is more like a slice of life, with events occurring all around outside it. What this results in is lines and shapes coming from outside, intersecting the picture plane. These can be stalks, the edge of a table, dishes and so on. These are lines that draw the viewer's eye in towards the centre of interest. This can be done directly, straight to the flower via a table edge or stalk, or in a circumspect way, by meandering flowers and stems interconnecting with others.

Numerous entry points are given around the composition, leading the viewer's eye from all directions towards the centre of interest. These are meandering journeys that you need to plan out in order to keep the painting interesting.

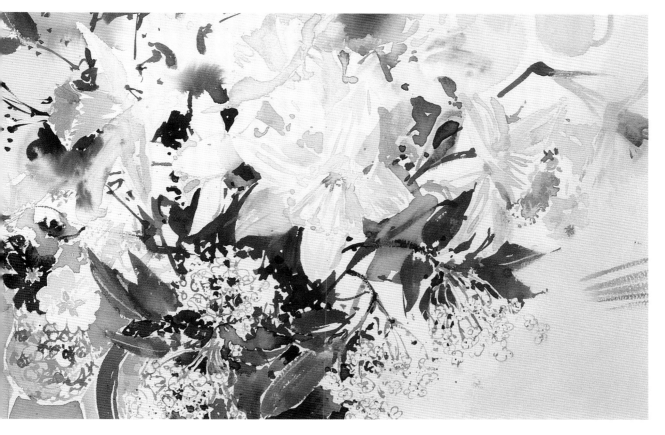

Early Daffodils,
30 x 48cm (12 x 19in)
Although this image appears loose with free forms, it still has lead-in lines and edges intersecting the edge of the picture plane to draw the viewer's eye into the composition.

Roses, Coffee Time: Demonstration

I have set up this still life with roses to demonstrate my method of forming a composition. Starting with a small sketch, I work out the basic layout. It is with the sketches that I determine focal points and all the lead-in elements intersecting the edge of the proposed painting. I will stick to this design throughout the whole image.

STAGE 1

This is a classic example of my thumbnail sketch for the first stage. It is the bare essentials for a still-life composition drawn from life. Note from the erasures, particularly near the coffee cups, how I shuffled the objects around, like moving pieces on a chessboard. I was looking at how the viewer's eye might be drawn in and the scale of the flowers and vessels relative to one another. You can see on the right-hand side how I also adjusted the cropping to condense and compact the image a little.

STAGE 2

To begin the painting I used masking fluid applied with a piece of folded card to block in the roses. I laid an underwash of grey, partly to set the mood which underwashes can do very successfully, and also to emphasize the light tones of the roses. The underwash consists of indigo and a little raw umber. I then put in various delicate grey shapes, using my soft sponge.

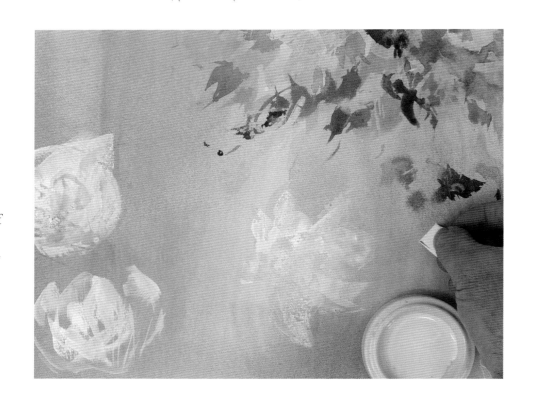

STAGE 3

In this stage the whole image is basically blocked in. I like to work left to right, top to bottom to keep the entire painting moving. Try not to dwell on one area that you enjoy or that has gone slightly wrong and needs correcting – if you do that the whole composition fails to cohere. One of the first things I like to establish is the tonal range of the image as a whole, so I put in the darkest of the darks and the lightest highlights. Note that the principal dark areas are diagonally opposite one another.

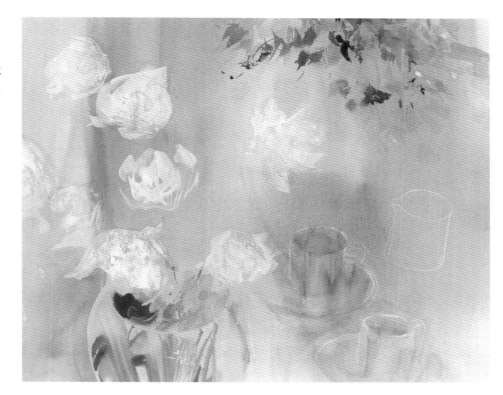

STAGE 4

The beauty of the grey underwash is that I can exploit a discrete amount of opaque white gouache. This use of body colour gives a subtle alternative to the white paper that has been masked out with the fluid. Another aspect of using white gouache is that small highlights can be added at a later stage and the gouache can even be used for drawing with highlights as shown by the small jug on the right. The best white to use for opacity is Designers Gouache permanent white.

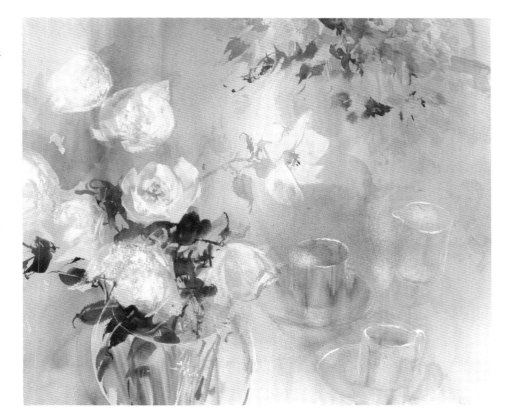

STAGE 5

I wanted this painting to have a slightly ghostly quality, fading in and out with objects hinted at rather than stated obviously. To achieve this I needed edges to appear and disappear into the background. This is a method referred to as 'lost and found'. Even the forms themselves were softened to give them a 'sfumato' hazy look. Achieving this look necessitated gentle softening and blending with a soft natural sponge seen here.

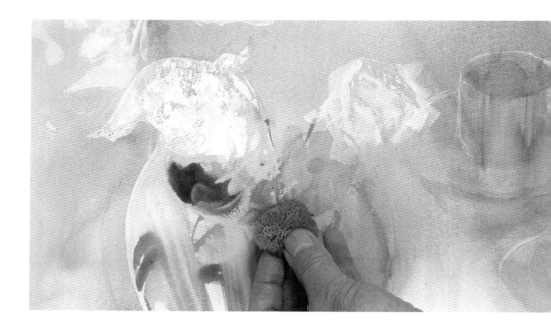

STAGE 6

The bulk of the work has now been done. The masking fluid has been removed, leaving a bit of a mess. In some areas the whites have been added, such as highlights on the cups, saucers, jug and glass vase. This is the exciting stage of a painting and the questions start. Is it saying what I want it to? Is it balanced? What do I need to do to complete it? Here I noted, 'Add centres to roses and decoration to the cups; strengthen tones where necessary; add further foliage, including pale distant tones; and add more detail to the flowers in the background. Just as important is knowing when to stop, as overworking can kill a painting.

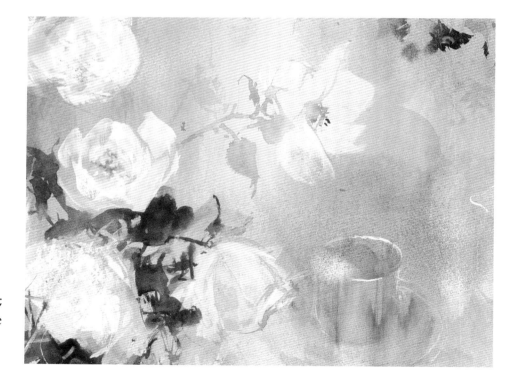

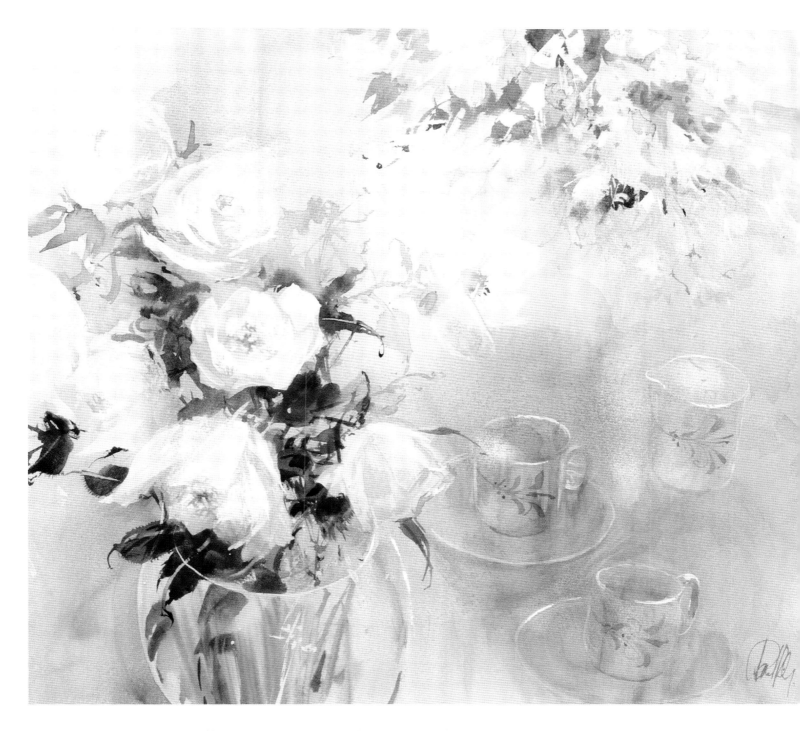

FINAL STAGE: Roses, Coffee Time, 42 x 50cm (16½ x 19½in)
Many of my compositions are cyclic in nature. I like the parts of the image to wind into and out of the space, rotating around the focal point gently glowing in the middle. I find it says what I wanted it to.

CHAPTER 4

COLOUR MAGIC

Colour is a major part of our lives, even if many of us may not consciously notice it day-to-day until our attention is caught by something especially pleasing. Artists, though, pay it special note and being able to describe it with the pigments at our disposal is a privilege and should be enjoyed as such. Flowers occupy a special place in the colour spectrum, showing as they do the vivid contrasts in primaries and secondaries that outshine almost anything else in the natural world. As painters we endeavour to replicate their colourful effervescence, even while knowing full well that nature has the edge.

Nature's Chaos, 33 x 51cm (13 x 20in)
Using black in a watercolour is considered to be a prelude to disaster. However, I decided to give it a go using its massive contrast in tone to add drama and excitement to the blooms.

Primary colours

While yellow, red and blue are the primary colours, there is in fact no such thing as an absolute primary colour in paint because each one is biased towards the other two primaries. Therefore yellow can be blue-biased (greenish) or red-biased (slightly orange); red can be blue-biased (slightly mauve) or yellow-biased (slightly orange); and blues are either red-biased (violet-tinged) or yellow-biased (greenish).

The six colours in the photograph (right) constitute the basic primaries and are my minimum palette. All the rest are variations on the theme and have special pigment properties. Watercolour is unique in that the way the pigments behave on the paper is different from those in any other medium. They may be thin stains, transparent and clear, semi-opaque with covering power or granulating, giving textures. Most paint manufacturers give these details on their colour charts.

When painting flower petals, especially in primary colours, I always use staining pigments or the semi-opaque colours such as cadmiums very diluted to ensure transparency in the petals. When I am layering cadmiums I use a maximum of two and keep them transparent. Staining pigments can go up to three layers while remaining transparent.

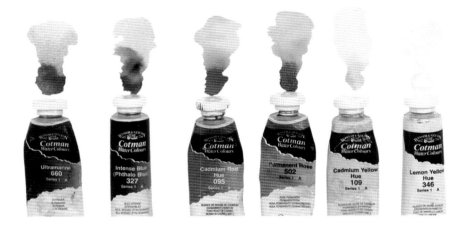

Primary colours From left to right, intense blue (phthalocyanine, stain); ultramarine blue (granulating); cadmium red (semi-opaque); permanent rose (quinacridone, stain); cadmium yellow (benzimidazolone, stain) and lemon yellow.

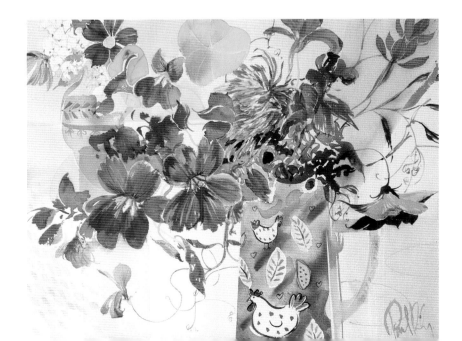

**Nasturtiums in Lucy's Vase,
38 x 47cm (15 x 18½in)**
All the primaries have been used here with red and blue dominant. Yellow is added discreetly as centres to the flowers, contributing much needed sparkle.

**Red and Blue Flowers,
21 x 28cm (8½in x 11in)**
Here I aimed for maximum contrast by setting red against blue. I felt it would add another kind of contrast if I used very soft edges, so the whole image was executed on saturated paper which I soaked three times. I then put the colour on in layers, which increased the intensity.

Colour contrast

Watercolour has a reputation for being a bit wishy-washy, but it need not be so. One can certainly obtain some very beautiful pale shades from even the strongest colours, but they can also be used at their full intensity. When you're planning an image you need to decide which tonal range you're after and stick to it.

Even strong colours can be diluted to very pale shades (above left) as shown in the sketch, which uses a delicate, light-toned range, showing a particular atmosphere and lighting.

The pigments at full strength (above left) demonstrate how intense they can be (above right).

Colour distribution

To create harmony and balance in a painting, a specific colour needs to be distributed throughout the whole image. The examples on the right show how this is achieved.

This is a form of orchestration I use in most paintings, the objective being to encourage the viewer's eye to wander over the whole image. If a particular colour were isolated in a corner, for example, the eye would be concentrating on at that point in the painting. Below you can see how I have triangulated the mauves.

This diagram shows how to distribute colour throughout a painting. I call the main method 'triangulating' the colour (top left), but this is not a fixed geometry (below left). Colours are painted in different ways, from blotches that might be flowers to dots and delicate washes (top right). This can work in a simple image (bottom right).

Mauve and White Medley, 21 x 28cm (8½ x 11in)

In this painting you can see how I have triangulated the shades of mauve in the composition.

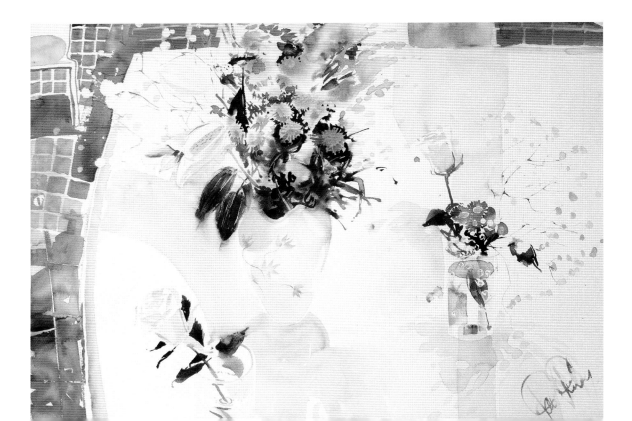

Complementary colours

Certain colours when adjacent to each other are particularly exciting and vibrant. These are red with green, yellow with violet and blue with orange. This is because, in the case of red and green, for example, the primary red is adjacent to a secondary colour made up of the other two primaries (yellow and blue = green) This means the eye sees two colours but the brain is aware of three.

These pairings, known as complementary colours, can be used in a composition to give added impetus. In the three paintings here you can see how they have been exploited. In *Autumn Leaves and Berries* I have used the red/green conjunction; in *Violet Cyclamen and Cherries*, violet and yellow; and in *Cornflowers, Fruit and Candles*, blue and orange. In each image I have varied the pairs in both hue and tone. In the yellow/violet painting, for example, the yellow alternates between cadmium and lemon yellow and the violet between blue-violet and red-violet hues.

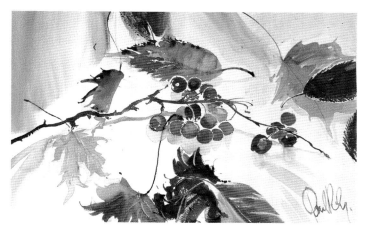

Autumn Leaves and Berries, 32 x 51cm (12½ x 20in)

Violet Cyclamen and Cherries, 32 x 42cm (12½ x 16½in)

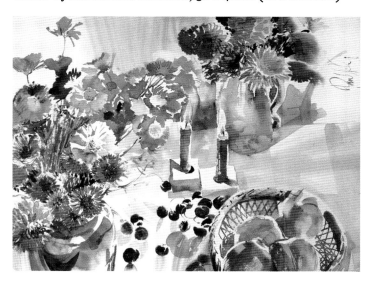

**Cornflowers, Fruit and Candles,
56 x 76cm (22 x 30in)**

Earth colours and greens

It is surprising how many watercolours end up looking rather muddy, which is something to be avoided. This is usually due to a preponderance of brown, though in fact brown, grey and beige colours are very beautiful and should be seen and exploited as such. These colours, referred to as 'tertiary', are a mixture of all three primaries.

A grey comes from red, yellow and blue dominated by blue, while brown is the same three colours dominated by the red, and beige where the dominating colour is yellow. Tertiary greens also exist where there is a certain amount of red in the mix, for example cadmium yellow plus ultramarine is a tertiary green because there is red present in both colours. Theoretically, all the tertiaries can be mixed using the primaries, but it is also possible to purchase ready-made colours. In the array of colours shown right there is a range of earth colours, so-called because of the origin of the pigments, and some greens.

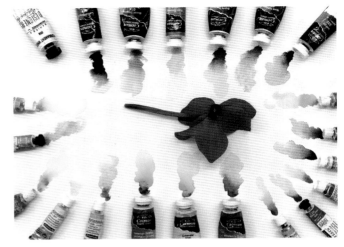

Although you can make your own greens from a combination of yellows and blues and you can make brown and greys from all three primaries, many artists find it convenient to use a few ready-made versions.

Dried Grasses, Onions and Garlic,
56 x 76cm (22 x 30in)
To achieve the variety of tertiary colours in this painting I mixed some from the primaries plus a selection from the earth colours. Most of the shadow greys were mixed using phthalo blue, lemon yellow and permanent rose.

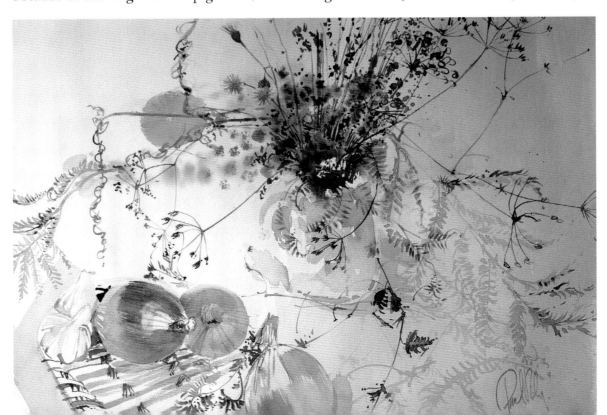

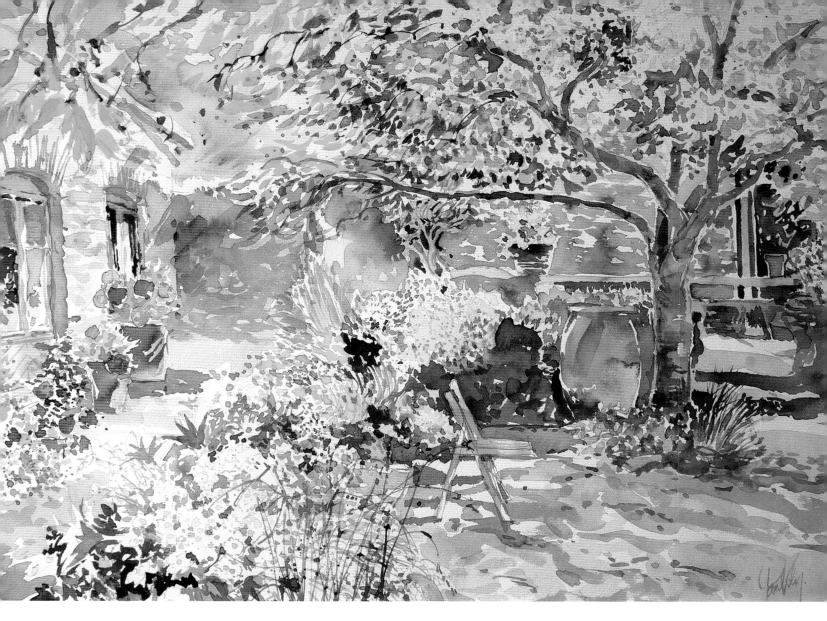

Courtyard with Pink Chair, 56 x 76cm (22 x 30in)

This leafy courtyard was a profusion of greens touched with the occasional complementary reds. For all those greens I needed a full palette. There were true secondary greens (no red) from yellow to blue in hue, along with tertiary greens interspersed with cadmium yellow and even some browns. I like lots of different colours, so I experiment with all sorts of combinations. The basic colours are raw sienna, burnt sienna, raw umber and burnt umber. The burnt versions are more red than the raw ones. These cover most browns while Payne's grey, indigo and black sort out the greys. Greens are an essential part of the image and here we see some very useful ones, for example may green, intense green, perylene green plus the rest for occasional use.

Reds

Red is an extraordinary colour that seems to be dominant in the flower world. There are three basic types of red pigment: cadmium, quinacridone for the blue-biased reds and pyrrole for the yellower reds.

Here I show three versions of cadmium red (all opaque) which can sometimes confuse people. They are the same basic hue but they vary in tone from light to dark by becoming slightly less yellow and more blue. This is useful when you want to darken a red flower. If you want to go any darker you will need to choose a quinacridone red.

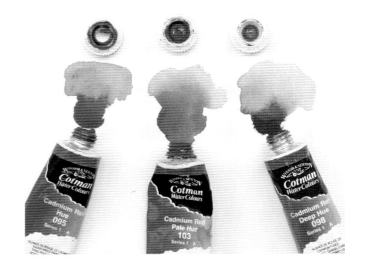

Cadmium red This comes in three hues – cadmium red; cadmium red pale; cadmium red deep.

Autumn Bouquet with Pomegranate, 56 x 76cm (22 x 30in)
The reds here are analogous, moving from violet to blue red (permanent rose) yellow red (cadmium red) to yellow, each one singing with their partners.

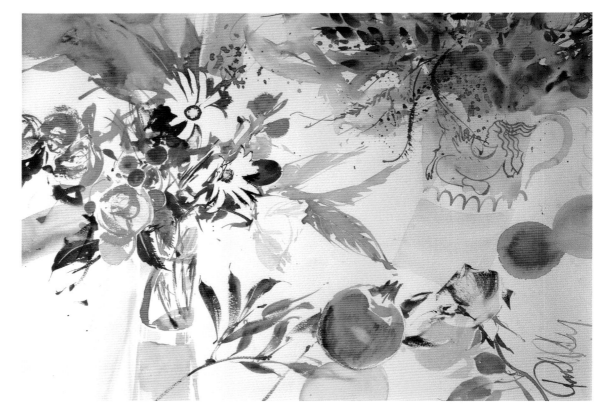

Alternating hues

This is one of the exciting techniques I use that can enliven colour much in the same way that complementary colours stimulate the viewer. It was a discovery made by accident while I was splashing paint around.

Shown here are the six basic primary pigments I use, painted in tones varying from very pale to dark as possible. I have then added a very small touch of the alternate hue which sets off the basic colour – for example, the lemon yellow has a small touch of cadmium yellow and vice versa, the cadmium red has a tiny touch of permanent rose and so on. What happens is the eye sees one primary colour but is aware of all three; cadmium red (which has yellow in it) plus permanent rose (which has some blue). The painting below exploits this.

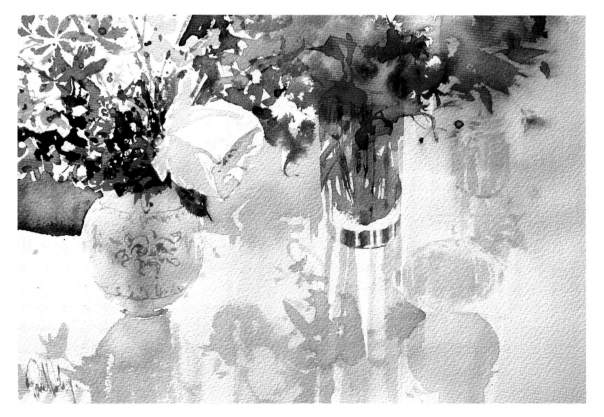

Flowers with Lemon, 31 x 51cm (12¼ x 20in)

In order to get each red to sing I have introduced a touch of the alternate hue – a touch of orange red into the violet red in the glass, for example. The blue flowers, predominantly yellow biased, have a touch of the violet blue added. I have done the same with the lemon.

Mixing greys

Greys are important, for you cannot have whites without them – white flowers have their shadowed sides, therefore need greys to explain their form. Consequently, one must get to grips with mixing greys.

Grey is a blue-biased tertiary. Shown here are two groups of grey, the ones on the left mixed from staining pigments while on the right I have used semi-opaque and granulating pigments. The mixes on the left are ideal for flower petals. Note that grey goes from blueish to greenish to violet. This requires control to get right, since using Payne's grey, ultramarine, indigo or black makes the grey go grainy and will kill the transparency of the petals. Mixes of phthalo blue, lemon yellow and permanent rose are the way to go.

Orchids 1,
14 x 23cm (5½ x 9in)
The luminosity of this painting depends on the extravagant variety of greys. Note the violet tints, blue tints and green tints. I have exploited the use of subtle yellows to complement the violet greys and splattered lots of reds amongst the green greys.

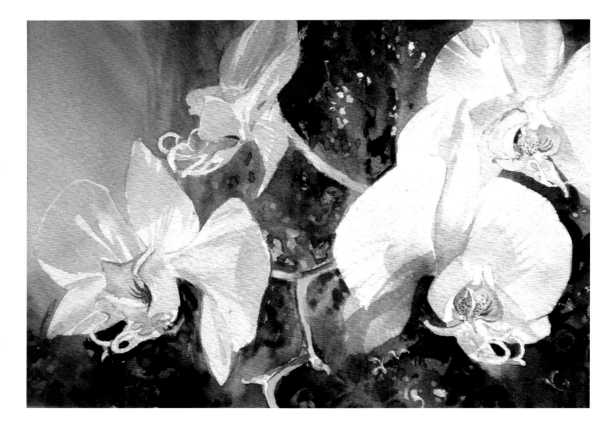

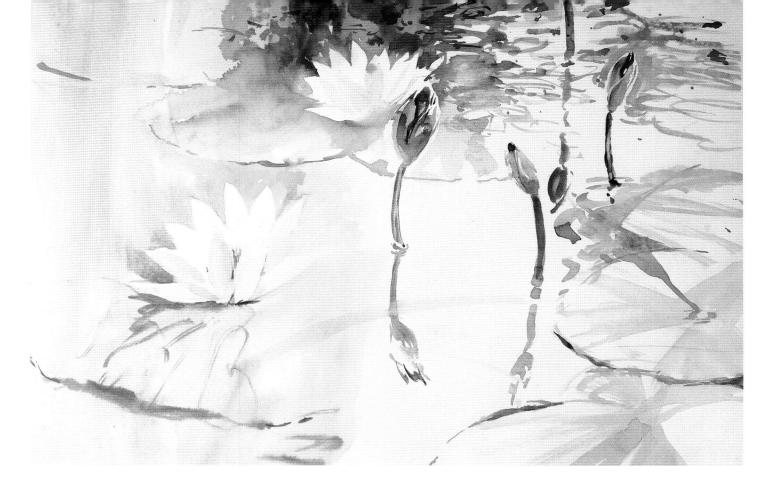

Waterlilies in Bali, 30 x 47cm (12 x 18½in)
Note that the background tone in this painting varies from
one flower head to the other in order to create more interest.

To make white stand out, one needs to deepen the tone adjacent
to it. This will be the background and has to be handled carefully,
since the tendency with putting a darker area behind the flower is
that one tends to 'halo' it. The trick is to create the impression that
the background carries on to the edge of the picture plane.

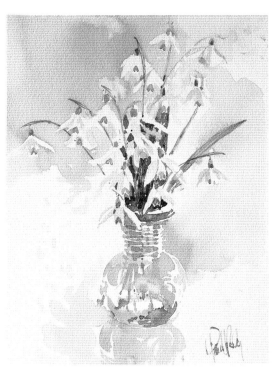

Snowdrops in a Green Vase, 32 x 22cm (12½ x 8½in)
Here the tone is more subtle so as not to distract attention from
the smaller flower heads. The glass and shadows are all greys
from the stain colour mix, with a little intense green thrown in.

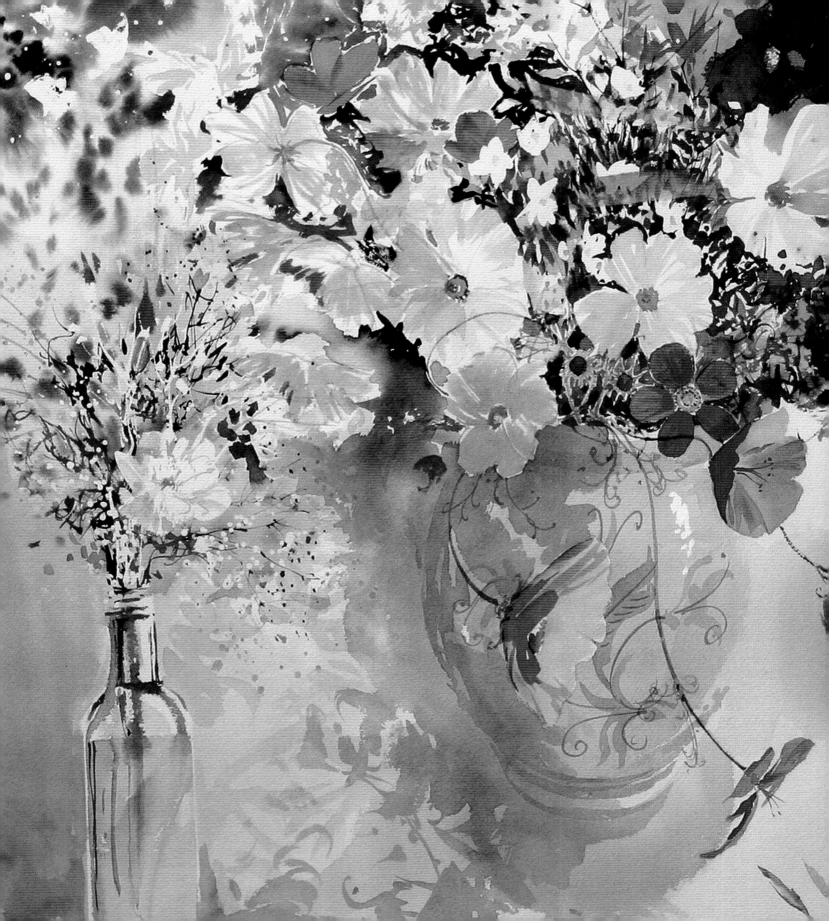

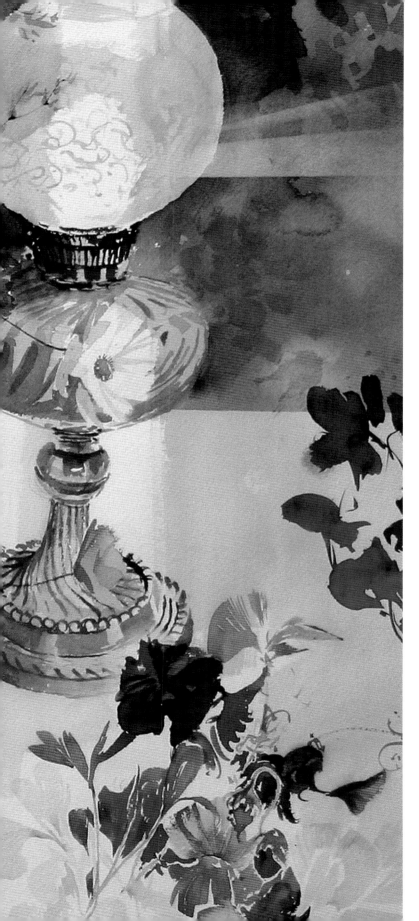

CHAPTER 5

LIGHT

Portraying a specific light source and its colour adds magic to any flower painting. Light reveals form, it creates shadows and shadows have patterns. It has varying degrees of intensity and taking advantage of this allows you to control the mood and atmosphere of your painting. In this chapter you will discover how to use different light sources to give character to your work.

A Profusion of Flowers with Oil Lamp,
51 x 70cm (20 x 27½in)
It may seem old-fashioned but I adore candle and lamplight. The special golden glow has a magical effect on its surroundings, especially white surfaces and flowers.

Shadows

Determining the light source is crucial to understanding its effect on a painting. In the diagram (right) I have shown the three principal light directions and their consequences. Light from the front causes little or no shadow and is used to reveal pattern – ideal for a decorative painting. Light from behind, known as *contre-jour*, causes drama, with long forward shadows and light halos around the objects. The side light reveals form, either from the left or right, producing shadows of differing length and direction. Shadows are objects in their own right and should be considered as such. They have a beauty all of their own.

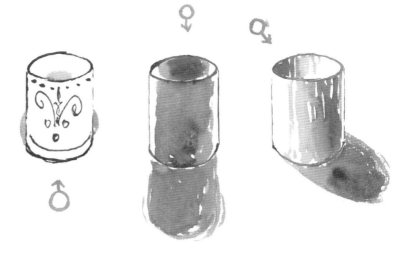

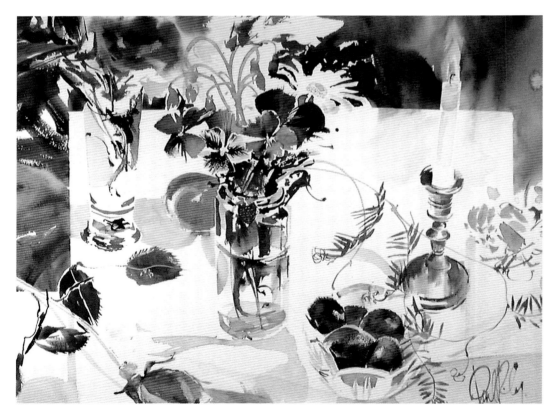

Bouquet and Plums,
51 x 70cm (20 x 27½in)
Light radiating from the candle produces dark shadows beyond the flame. Light passing through glass containers has a character all of its own.

Spring Flowers in Candlelight,
45 x 56cm (17¾ x 22in)
Shadows are not just grey smudges; they can have iridescent colours, especially if the light source is coloured, as is this candlelight. Don't hesitate to exaggerate.

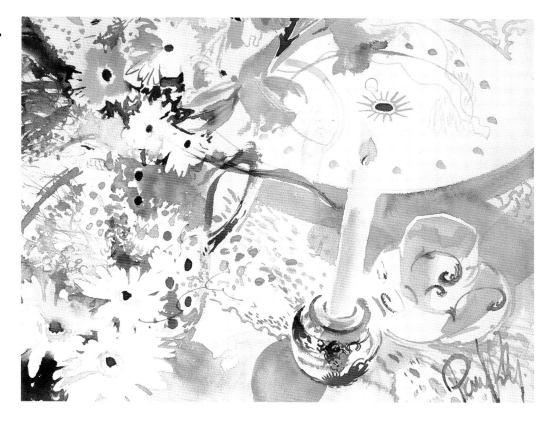

Many people are not sure of the difference between shadows and reflections, so I have drawn an explanatory diagram to illustrate the point. A shadow is produced by a light source radiating from a particular height and direction. Seen here is a cylinder lit by two light sources – a window and an electric light. This produces two shadows called umbras, and where they cross is a darker shadow referred to as a penumbra. Note that the shadows have quite specific shapes. A reflection is an inverted image of the object seen on a reflective surface such as a polished table, mirror or water, as shown at the bottom of the cylinder.

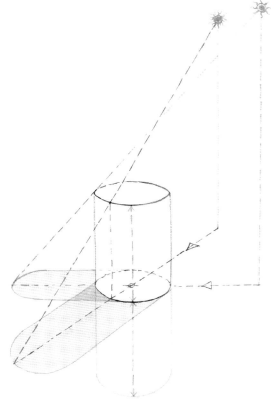

Candlelight

Light sources vary in intensity. The sun is the brightest of all, followed by artificial light, of which halogen is the brightest, then fluorescent, then tungsten. The type of light produced by a flame, from oil light to candlelight, is dimmer – the friendliest light. The brightest light is bluish, gradually getting red and yellow as the intensity diminishes, so candlelight creates a beautiful golden glow that suffuses a painting with reds, yellows and oranges. The flame has to be the lightest tone, which I gently soften with a sponge at the end of the painting. For contrast, the wick is dark with a tiny orange tip.

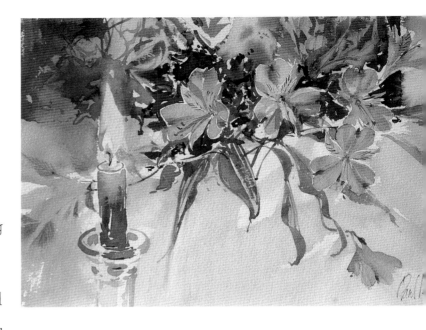

Alstroemeria and Candlelight, 30 x 50cm (12 x 19½in)
To obtain the effect of a candle flame a painting needs several contrasts: white against dark with a soft edge and orange hint, a violet core and black wick with a bright red tip!

Daffodils by Candlelight, 14 x 23cm (5½ x 9in)
The orange light emanating from the candle radically affects the colour of the white petals. This is especially noticeable where the flowers are closest. Note the merging of the colours in the candle itself, moving from orange to yellow to violet to blue.

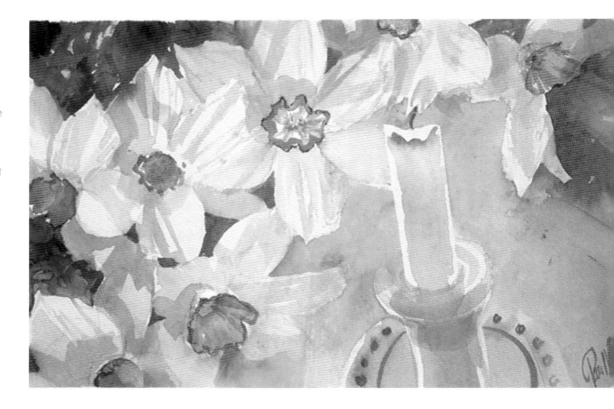

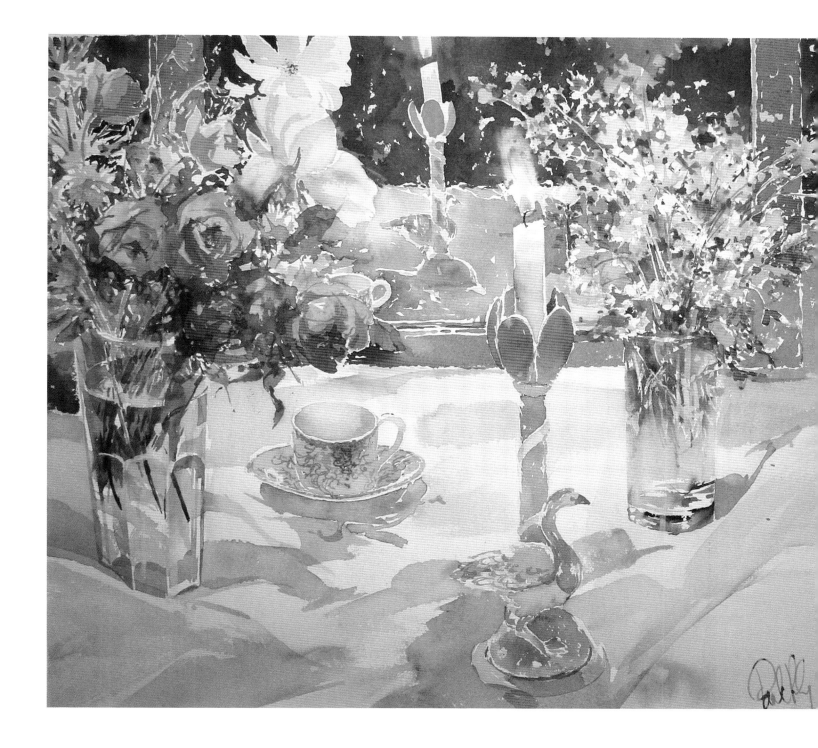

Flowers with Goose Candlestick, 43 x 50cm (17 x 19½in)
This complex painting challenged me in many ways, with the inclusion of the mirror,
glass vessels and candlelight and a lot of negative painting. The wild flowers needed
extensive use of masking fluid. The roses were not easy, either.

Contre-jour

Contre-jour is a French phrase that has seeped into the artist's lexicon and describes anything that is backlit. The beauty of this form of lighting is that it reduces much detail to a simplified silhouette. This silhouette is usually dark in tone, the colours rich and moody. One special phenomenon is the halo that surrounds the objects as the light creeps around the sides. The shadows are very dramatic, linking the image with the bottom edge of the picture plane. To obtain these effects, either use a low spotlight or place flowers on a window ledge with the sun streaming in.

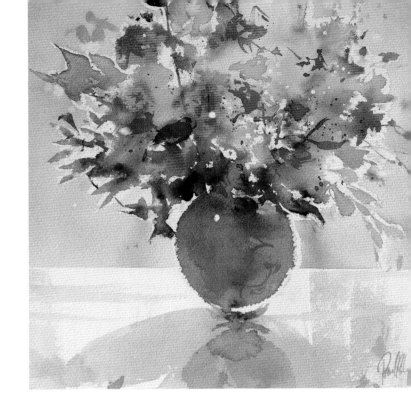

Abstract Flowers, 30 x 30cm (12 x 12in)
This relatively simple study shows how, by keeping all the tones and colours dark with soft edges, the effect of backlighting can be achieved.

Flowers and Reflections, 23 x 33cm (9 x 13in)
Back lighting glass is an especially lovely phenomenon. I have tried to achieve this by the simplest means. Paint what you actually see not what you think you ought to see!

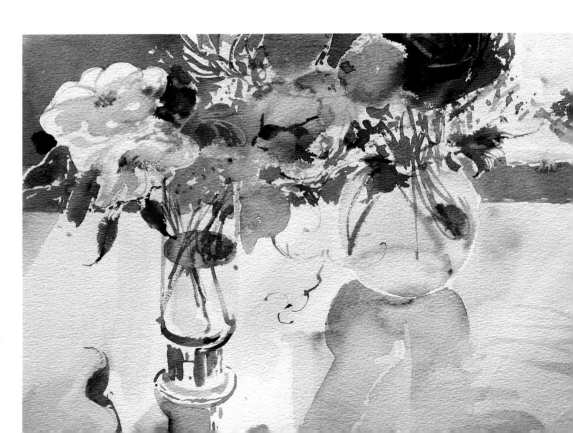

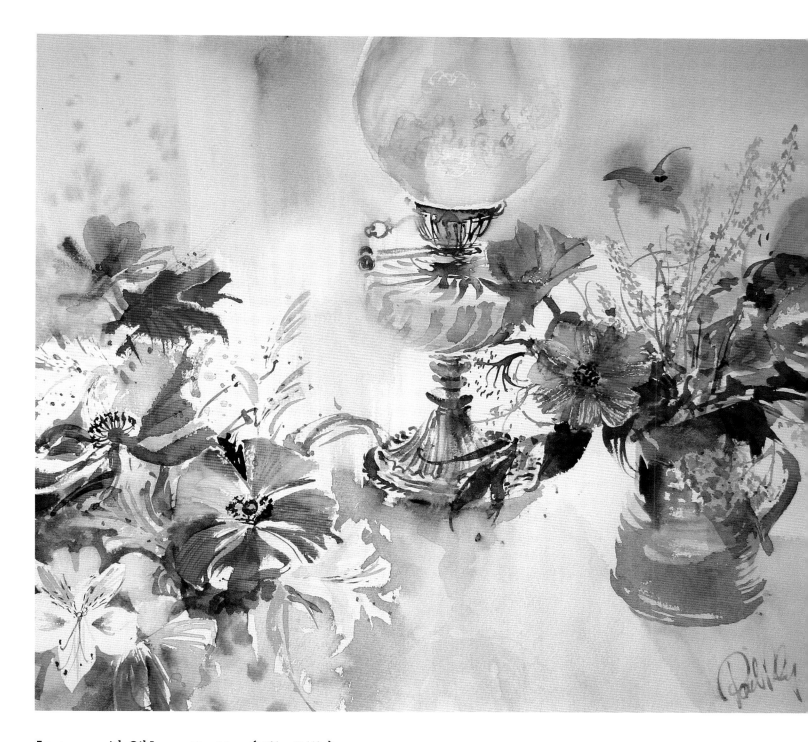

Anemones with Oil Lamp, 45 x 50cm (17¾ x 19½in)
The flowers and jug are in the foreground, therefore the oil lamp
provides the backlight. The light from an oil lamp is generally
soft and diffuse and should be painted as such.

White Orchids and Freesias: Demonstration

I chose a white orchid to illustrate the effect of candlelight on a white flower.
I decided to use white gouache to achieve the whitest whites of the orchids,
rather than masking out, which would be another option.

STAGE 1

First, I needed a drawing of the subject from life
to organize the layout of the objects. The orchid
is a quite complex flower to get right, so I made a
detailed study. The candlestick had a wonderful
three-point decoration, for which I devised a three
brush tool to do the job. I then practised to get it
right. Below is the grey underwash with the first
tentative feel for the image.

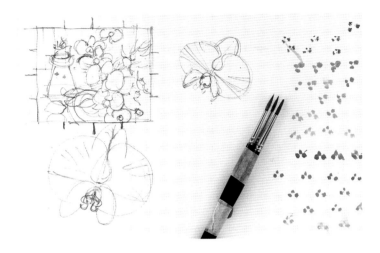

STAGE 2

I decided to draw with designer's gouache
permanent white paint, using a traceur brush
to produce a flickering stroke – I wanted the
linework to dance about as if animated by
the candlelight. Once the drawing was done
I started to build up the petals using a number 10
one-stroke sable brush. Note I have done the bulk
of the decoration on the candlestick.

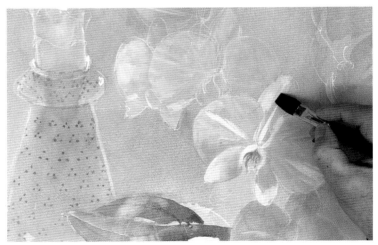

STAGE 3

I blocked in most of the image, including the flowers, candlestick, lemon and some of the foliage. I put down the two strong tonal contrasts from the flame of the candle on the back of the leaves nearest to it. I now had the full tonal range. I blended some of the edges to give depth and lightly indicated the forms of the shadows.

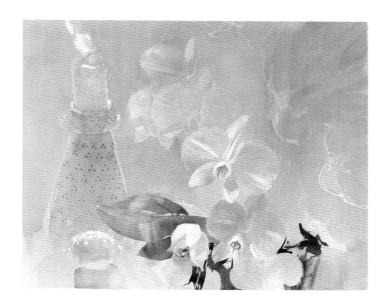

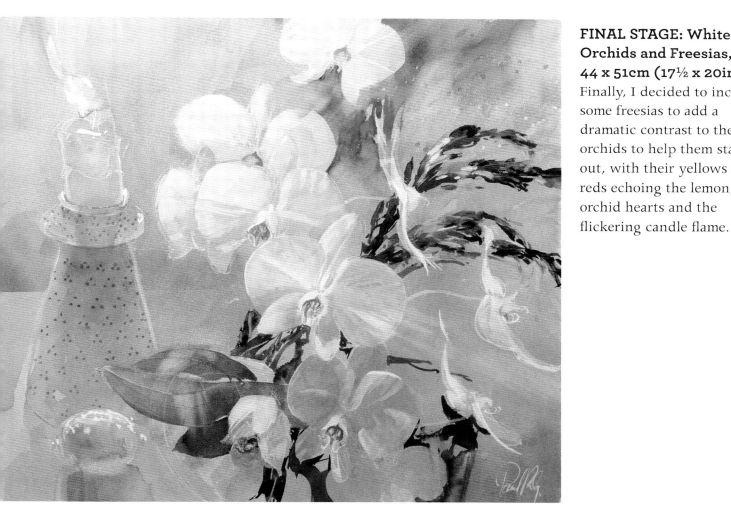

FINAL STAGE: White Orchids and Freesias, 44 x 51cm (17½ x 20in)
Finally, I decided to include some freesias to add a dramatic contrast to the orchids to help them stand out, with their yellows and reds echoing the lemon, orchid hearts and the flickering candle flame.

Oil Lamp with Daffodils: Demonstration

Sequencing an image involving lamp light is fairly complex. I start with the clean, clear colours of the pale flowers, then the dark contrasts of leaves and dark flowers, gradually working toward the lamp light. This process enables me to control all the negative painting involved.

STAGE 1

I arranged the three objects in my painting into three spatial zones, the small posy of pansies to the back, the lamp in the middle and the daffodils in the foreground. This meant that when the lamp was lit the posy would receive light while the daffodils would be against the light in partial shadow.

STAGE 2

It is important at the beginning of a painting to put in any masking that is needed. In this image I used masking fluid applied with a fine sable brush to draw in the delicate engraving of the lamp's glass bowl. In front of the daffodils were some bright orange dogwood branches, so I masked these out as it would be almost impossible to paint them later otherwise.

STAGE 3

The midway stage of a painting is where one must get all the colour variations of tones established. I tried to avoid tightening the brushwork, preferring to keep the strokes loose and fresh and leaving the shapes of the vase and lamp base with no hard edges. That way I could create the effect of light creeping softly around the forms.

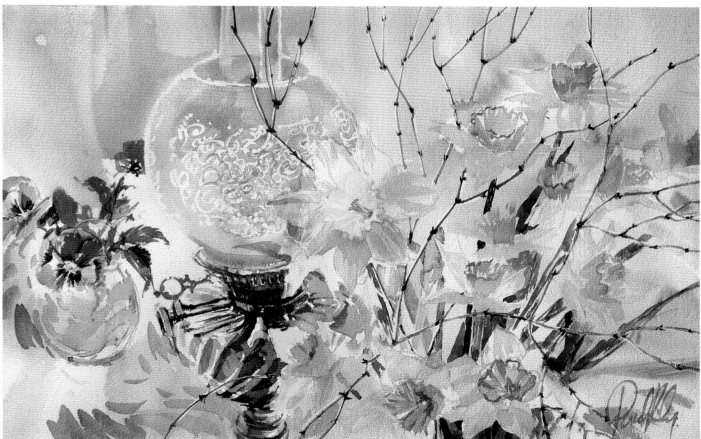

FINAL STAGE: Oil Lamp with Daffodils, 33 x 51cm (13 x 20in)
The masking fluid has come off and the flowers are completed. The lamp bowl has been painted a soft orange using permanent rose and glowing orange; this reveals the extra lines put there with the masking fluid.

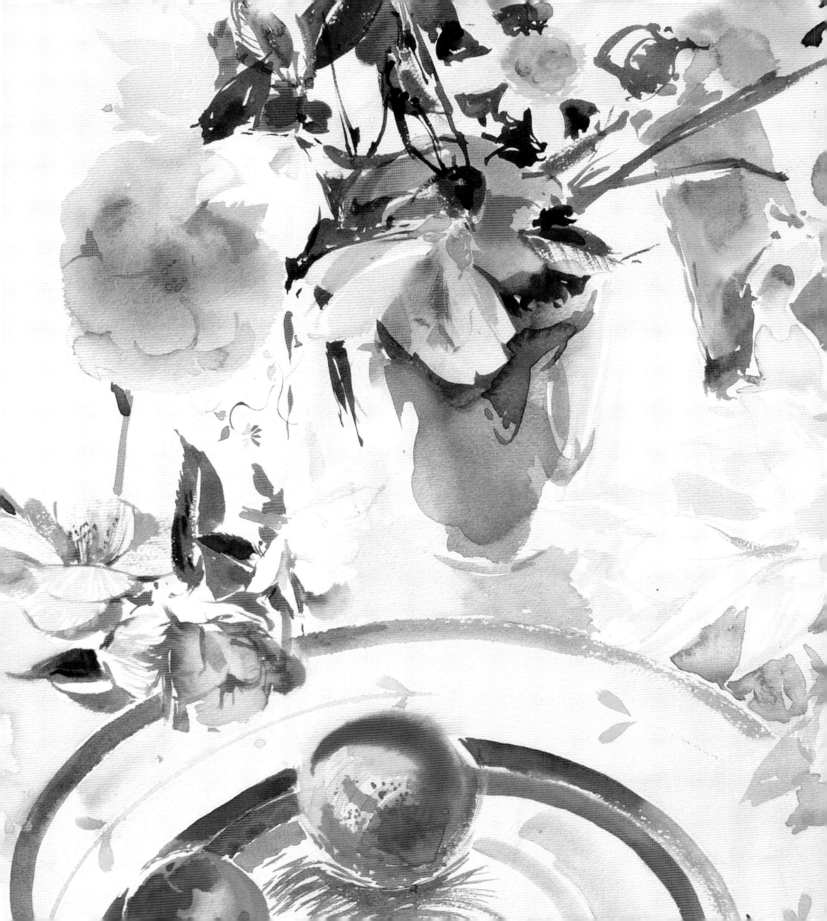

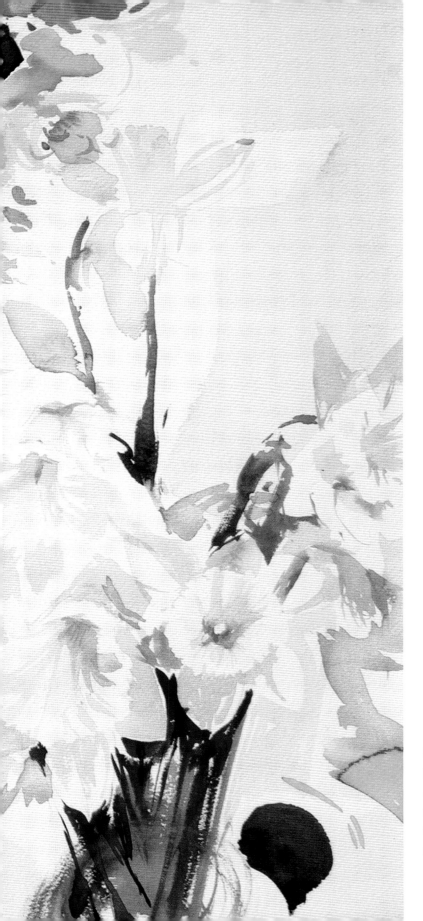

CHAPTER 6

STILL LIFE

The French term for still life is *nature morte*, meaning 'dead nature', but this certainly doesn't apply if you include the vibrancy of flowers in your composition. To me, arranging a still life is a little like a game of chess; you place your pieces in such a way as to have the maximum effect on the whole game. The orchestration of flowers and objects can generate different moods, atmospheres and feelings; it is not just a random collection. I love bringing flowers into the home or studio to paint. It's like letting in sunshine, and even in winter this is possible.

Camelias and Fruit,
56 x 76cm (22 x 30in)
A still life shouldn't be just a collection of objects: everything should interrelate; it should be a feast for the eyes.

Seeing the possibilities

When I am teaching students, I like to think of us as 'the looking class'. Painters enjoy the very special luxury that it's a bona fide occupation – we can stand and stare, and the more we look the more we see. What I look for are juxtapositions: the special way objects interact with one another; the way colours harmonize or clash; how shapes interlock and have their echoes with other objects.

When it is time to commit to a composition, there is a limit to how much shuffling of objects needs to be done. It is possible to make things a bit too contrived, losing the spontaneous feel that certain arrangements have. Formal flower arrangements look just that – formal. I prefer the more accidental look – odd and intriguing.

Looking at Azaleas,
51 x 70cm (20 x 27½in)
The more you look, the more you see. Notice how the hard shapes – window and table edge – help to reveal the fragility of the flowers.

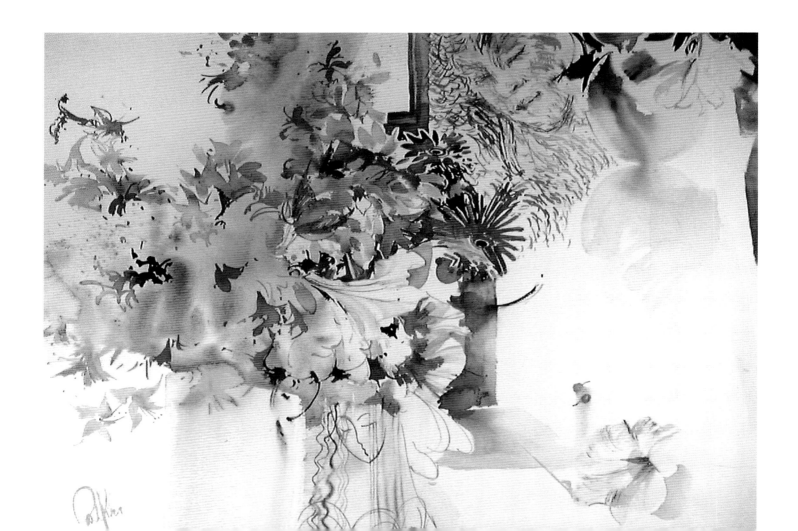

Vibrant Flowers,
51 x 70cm (20 x 27½in)
Flowers and objects can
interchange in character. Petals
can become butterflies; roses
screwed-up coloured paper.
Seeing in this way, you can
turn a painting into a poem.

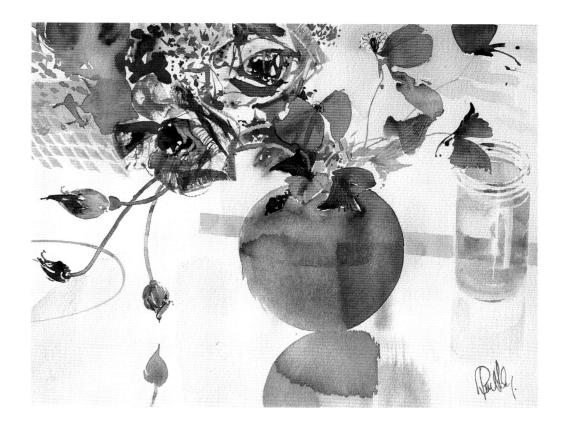

Still Life with Lilies,
56 x 76cm (22 x 30in)
If you let the image overlap the
edges of the picture plane you can
not only draw the viewer's eye in,
you can also give the impression
that the picture has such vitality
it is exploding out of its borders.
This, coupled with the spinning
effect of the bowl here, creates
a dynamic impression.

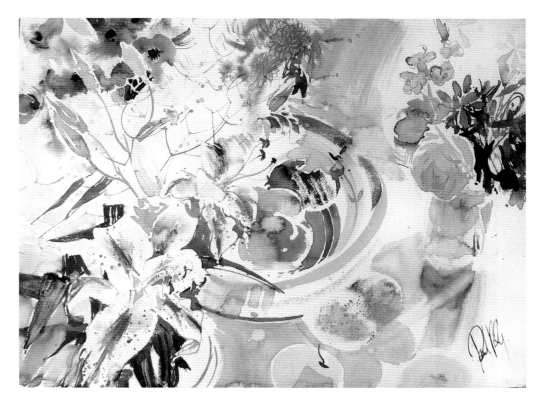

Abstraction

It is said that less is more, and it is true that a lot can be conveyed with mere suggestion. Abstracting means paring down to the bare essentials, giving just enough information to inform the viewer of your intentions. I call this giving visual clues. A simple brushstroke can evoke a dish, an apple, a glass jar. Oriental painting developed a zen-like approach that inspires me to experiment with simple touches and evocations rather than complex realism.

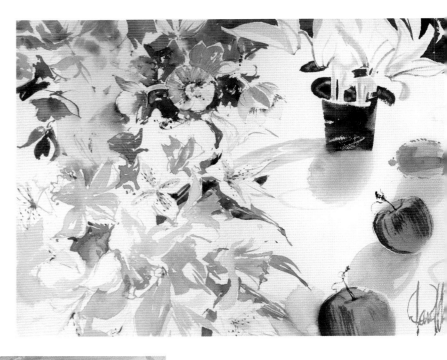

Potpourri of Fruit and Flowers, 56 x 76cm (22 x 30in)
Abstracting involves taking away, simplifying. Much of the foliage is gone. The red pot is reduced to a rectangle with some the flowers just drawn in. The object is to extract the essence of what you see.

Still Life with Dried Grasses, 56 x 76cm (22 x 30in)
I have tried to contrast the complex texture of the grasses with the simple shapes of fruit and veg. Contrasting in this way catches the eye, producing a strong pattern effect on the white of the paper.

Poppy and Heart Mug,
26 x 33cm (10½ x 13in)

This small painting attempts to convey the essence of objects and flowers while at the same time producing a dialogue between the visage on the vase and the heart on the mug.

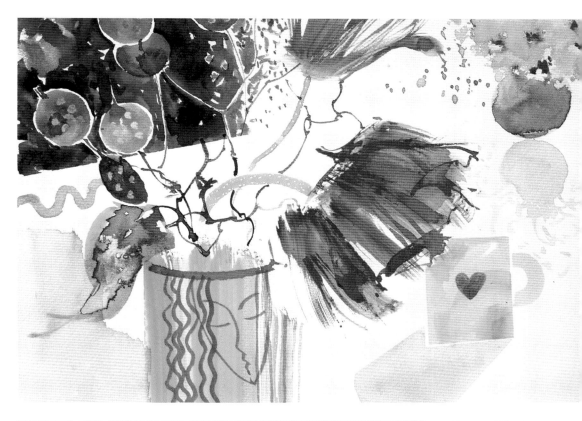

Still Life Study,
52 x 56cm (20½ x 22in)

It is possible with mere gestures to evoke a very realistic image. This is sometimes referred to as 'gestalt', where the whole is more than the sum total of its parts.

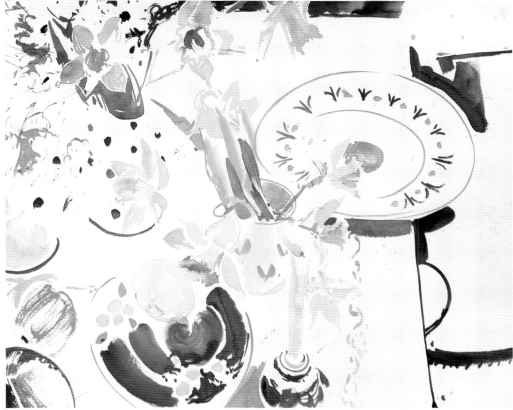

Exuberance

Not all of us are prone to give vent to our inner passions and feelings, but for some reason flowers bring out my lust for life and seem to want to burst off the paper. It's the flowers themselves that are so exuberant. They may be silent, but to me they seem to whoop with joy at their own beauty. In order to create these stunning effects I use a vibrant medley of colour and shapes that writhe and curl, producing a rhythmic sense of elation.

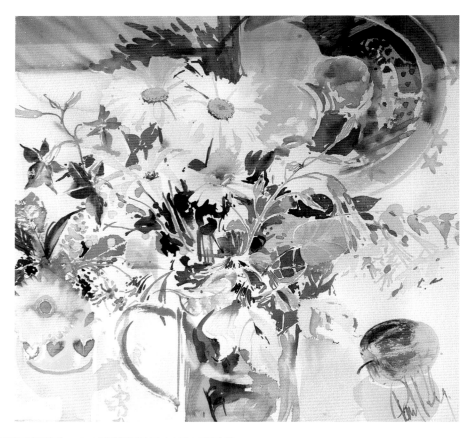

Summer Flowers and Apple,
56 x 60cm (22 x 23½in)
To create maximum effect I have used a simple cruciform composition. A variety of shapes, sizes and colours add to the exuberance of the painting.

Springtime with Tulips,
22 x 32cm (8½ x 12½in)
Big juicy shapes pulsating with colour always attract. The vases have been barely painted – only the spontaneous decoration and the dark background tones reveal their shapes.

Molla, 39 x 51cm (15½ x 20in)
I painted this picture in Norway, where in summer the sun never
seems to set. The countryside explodes with floral colours, so I used
quick, short colourful strokes to show this effect.

Tulips and White Roses: Demonstration

When arranging a still life about flowers, let them dominate. The vase is merely indicated, and the small handleless jug is allowed to merge into the background.

STAGE 1

I decided I needed to practise the rose first, so I did a detailed study in a mixture of watercolour and gouache. I wanted maximum drama, so I treated the foliage in a particularly expressive way. I find that leaves in a flower painting need to be kept to a minimum yet still set off the flowers to best advantage.

STAGE 2 (DETAIL)

For the alstroemerias, I use a soft squirrel round brush and work from tip to body. In this way I can draw and produce petal shapes in one. The aim was to describe their forms with spontaneous strokes. The tulips have an altogether different character, big and blousy. I used a round-topped filbert for these with broad, direct strokes.

STAGE 3

For blocking in the rose petals I used a 13mm (½ in) sable bright similar to a one-stroke brush but with slightly shorter hair. It is important that the brush has a really sharp edge and is relatively unworn.

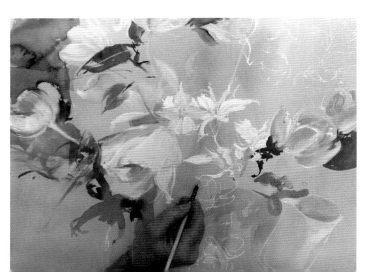

STAGE 4 (DETAIL)

Once the flower petals were dry I could put in the details. The various markings, anthers and stamens are painted using a miniaturist's sable brush, again using brisk touches so as not to make them look laboured. I added the stalks with my traceur brush, dragging out the pale ones with my fingernail. This can only be done while the paint is wet.

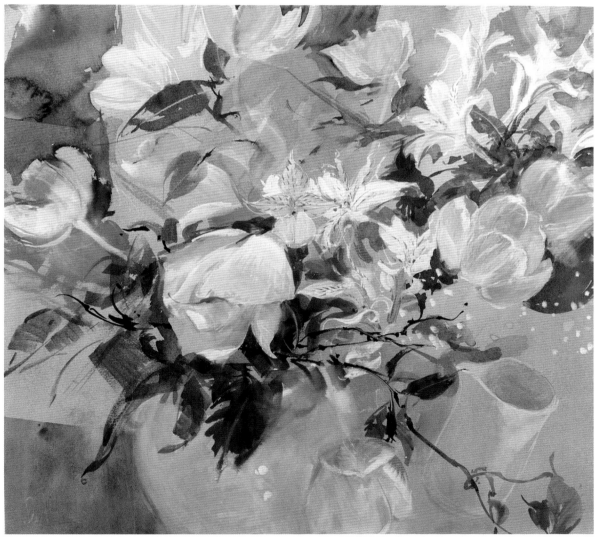

FINAL STAGE: Tulips and White Roses, 51 x 55cm (20 x 21½)

I have striven for maximum transparency in the petals, something that I love to aim for. By doing so I add to their fragility and vulnerability. It is sad that flowers die so quickly; painting them gives a degree of immortality.

Still life tips

When you are painting still lifes you will often include various objects such as bowls, vases, tablecloths and so on. Here are three tips to help you make these look convincing.

Ellipses

An ellipse is the distortion of a circular object that comes from viewing it at an angle, and you will often have to draw one. It is easy to get them wrong, but this approach should put you on the right path. First, note that the top of a circular object seen at eye level is simply a straight line, gradually opening up into a flattened circle as you look progressively down at the object (and up, if the object is transparent so that you can see the opposite rim). Here I show a glass of water as an example. To draw an ellipse in watercolour, first place a dot to represent the centre, then fill in the front and back, then the corners of the ellipse. These do not come to a point. In a broader object such as a dish, drawing the edges nearest to you darker than the farther ones explains the depth to the viewer.

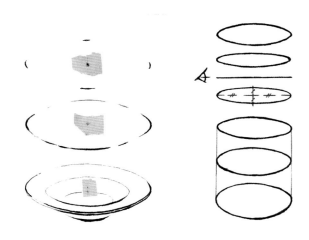

Textures

You will need to use different techniques for painting the surface of various materials, depending on their nature – hard, pliant, rough, and so on.

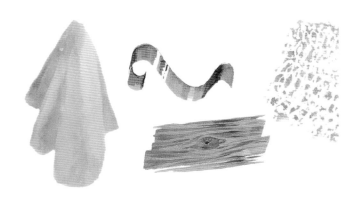

Soft fabric: Wet the paper, then when it is nearly dry, paint the colour. It will bleed slightly.
Silk ribbon: Use a flat brush, 13mm (½ in) or smaller, and show delicate and strong contrasts.
Wood: Paint a pale base colour and once it is dry add grain in two tones.
Lace: Use a masking fluid dispenser (see page 28) or cocktail stick and fluid. Draw the lace pattern with the masking fluid. When it is dry, add paint in a slightly darker tone than the blank paper. Finally, remove the masking fluid by rubbing with your finger or an eraser.

Symmetry

To get a vase symmetrical and upright first put a piece of tape down the middle. Then to the right draw the profile. Then mark a series of offsets. I use a strip of paper. Join the offsets together to form the left profile.

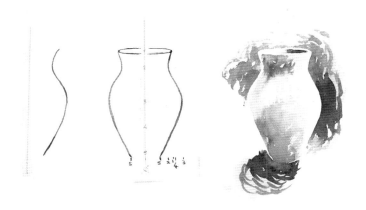

Medley of Flowers, 22 x 32cm (8½ x 12½in)

It is easy to let a still life layout get too complex. Keep it simple. Here I have an arrangement of basic shapes, reduced to geometric rectangles and circles. I then contrast these with the organic shape of the flowers.

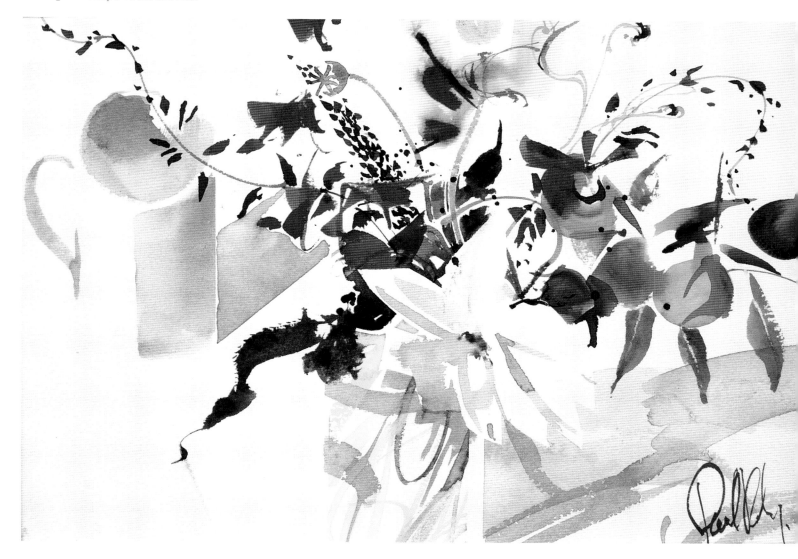

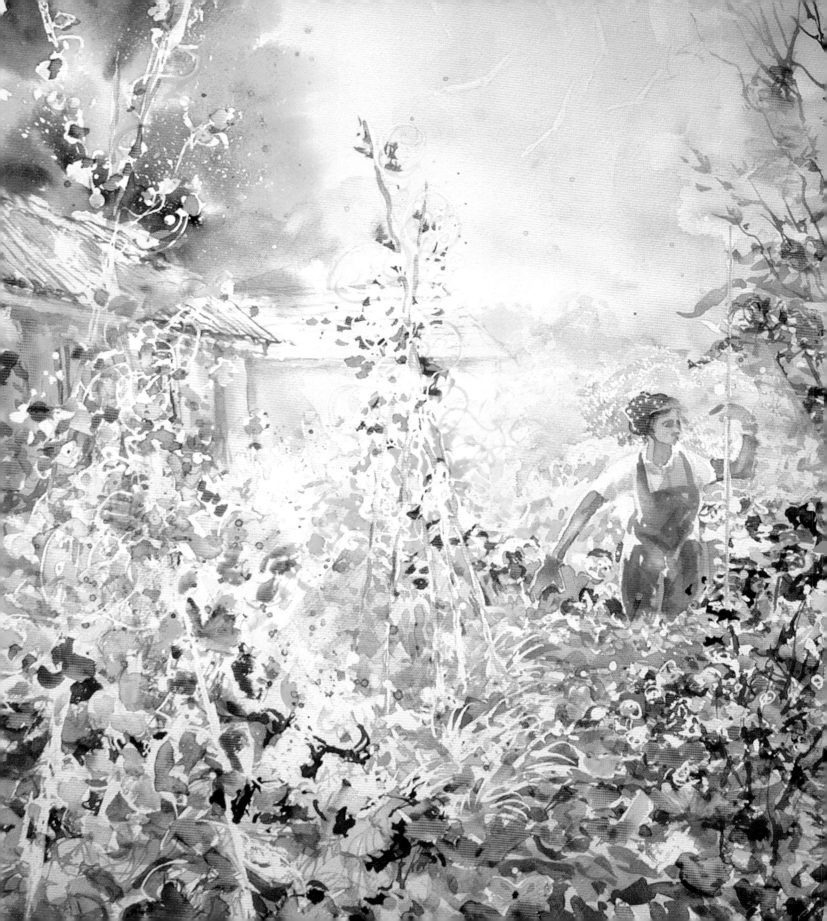

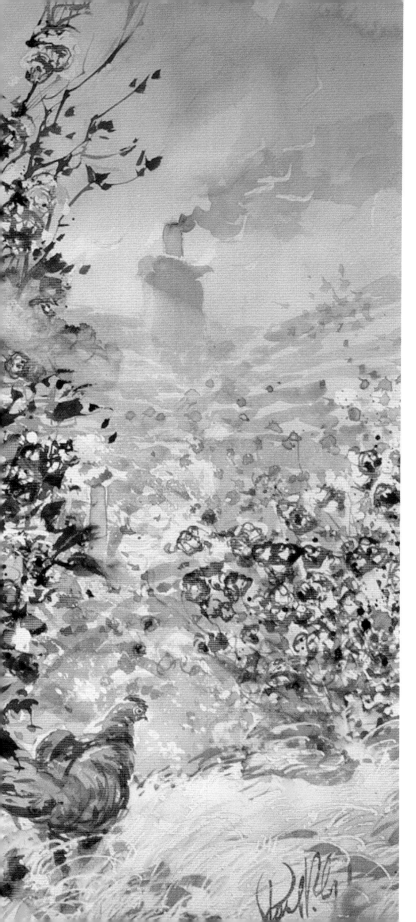

CHAPTER 7

FLOWERS AND FIGURES

Arranging flowers, tending them, accepting them as a gift, enjoying their presence on the table while we dine – we are fortunate that flowers attend us in so many ways and places. They are often associated with friends and family, so incorporating figures in your flower paintings, either as portraits or full length, is something you will probably want to do. It undoubtedly adds to the complexity of an image but is a worthy challenge.

Among the Flowers and the Vegetables,
51 x 71cm (20 x 28in)
Putting a figure into this composition gives a real focus with added interest. The colour of the woman's clothing is echoed throughout, helping to merge her amongst the flowers.

The vegetable garden

Many vegetables have very attractive flowers in their own right, and they are often combined with ornamentals, such as marigolds that have a role in controlling pests. The vegetable garden usually provides an excellent opportunity to include figures in your paintings, as a friend or relative doing some cultivation or harvesting will probably be there for some time. For an artist who is not very experienced, a model who may become restive and anxious to go can add tension to the process of completing a painting, so portraying someone while they are peacefully going about their tasks is ideal.

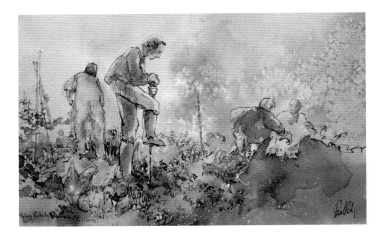

Tilling, 30 x 50cm (12 x 19¾in)
When someone is working it is a great opportunity to catch them in various poses. This pen-and-wash study is in fact one person in different positions.

Foraging, 30 x 41cm (12 x 16in)
In this image, and *Tilling* too, the pen and wash has an illustrative feel that romanticizes the subject. This is added to by the use of some salt in the background, which leaches out some of the colour.

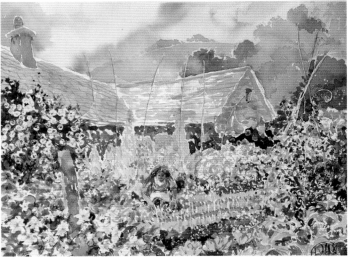

In the Veg Patch, 32 x 41cm (12½ x 16in)
To make this image work I have placed a strong dominant character towards the middle. The other shapes are positioned to add support and further interest.

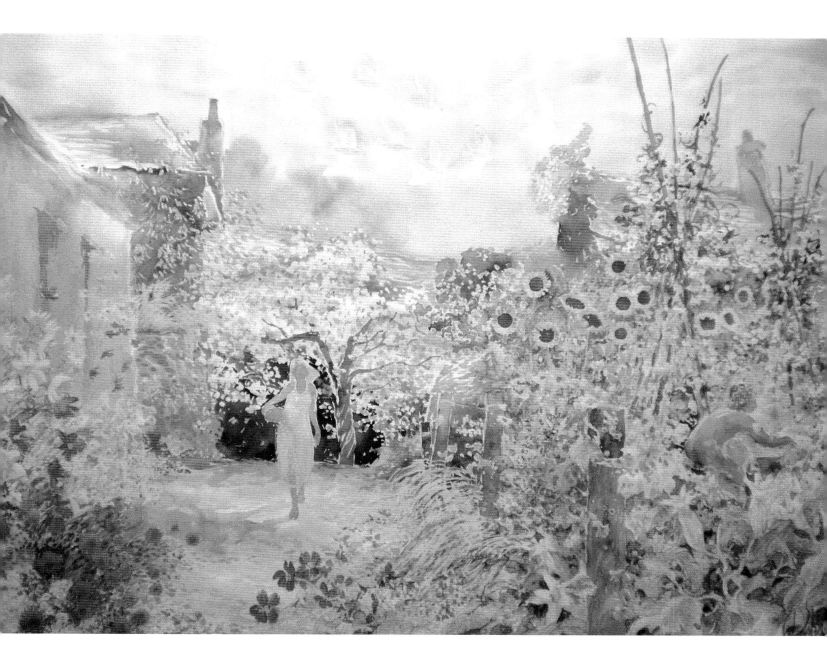

The Seasons, 88 x 115cm (34½ x 45in)

This large painting attempts to include everything: the flowers lining the pathway,
climbers on the buildings, blossom on the trees, the flowers on the vegetables – even
figures with flowers on their frocks! It was such fun to paint. Needless to say, there was
copious use of masking fluid.

Portraits

Including a portrait in a flower painting can produce an intriguing dichotomy. In fact the two are quite complementary. If the portrait is of a strong character, the flowers can add an extra dimension, and even establish a special mood. It is inevitable that the portrait will dominate so the flowers need to complement it in colour and tone.

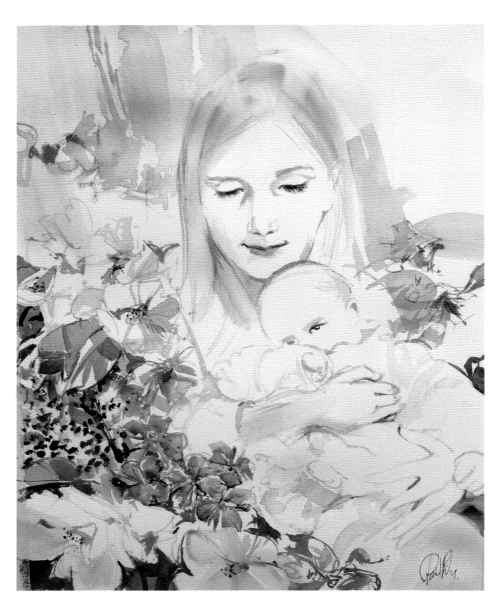

Sasha with Rosa, 51 x 41cm (20 x 16in)
I have deliberately left copious quantities of white paper behind to emphasize the delicacy of youth. Slight indications of form are added using a very pale mix of permanent rose and raw sienna. These are contrasted with the dark tones of burnt sienna and burnt umber for the eyes. For the lips I have used permanent rose and violet. The flowers are chosen to reflect a similar delicacy in order not to swamp the faces.

Lydia with Sunflowers, 56 x 76cm (22 x 30in)
This painting of Lydia is located in the south
of France. After a morning spent picking wild
flowers and sunflowers and after a good lunch,
I discovered a small bird that had been killed in
a storm the night before. The portrait of Lydia,
therefore, hints at a story that the viewer can
only guess at.

Stylizing

Along with painting I love pottery, and the pots I make are usually vehicles for me to experiment with decoration – quite often plants, but also the human form. If I don't have a particular dish or vase to go with my idea for a flower painting no matter; I make one up! Ideas for stylizing the figure can be found in ceramics from all over the world, together with simple patterns.

Two Muses, 51 x 71cm (20 x 28in)
The decorations on Greek ceramics fascinate me. The sinuous line, the simplicity of form is exquisite. I have tried to imply these qualities with the flowers adding their own linear character. To get these perfect circles I taped a round sable brush onto an ordinary compass.

Lovers with Pineapple, 56 x 76cm (22 x 30in)
One could be forgiven for thinking that all kinds of metaphors are inherent in the objects surrounding the lovers. I assure you they are in my subconscious. Note how I have stylized many of the items shown, thus linking the natural forms with the decorative faces.

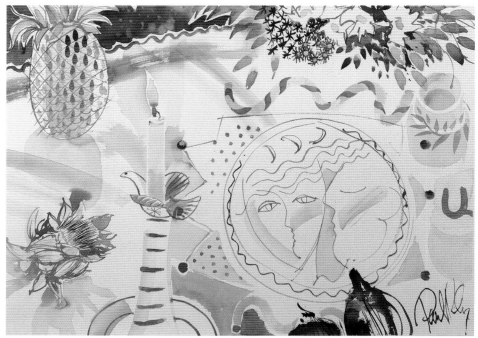

Blank Canvas, 88 x 115cm (34½ x 45in)

An artist can sometimes be scared of a blank canvas, but in this instance, with the courtyard thriving with new spring growth, I couldn't wait to get started. The figure, representing myself, is imagined and stylized as I could not have seen this stance in a mirror. When you are painting outside and want to include a figure, first prepare a drawing, then scale the imaginary figure to fit the image. If necessary get someone to stand in the position required then adjust the sketch to suit.

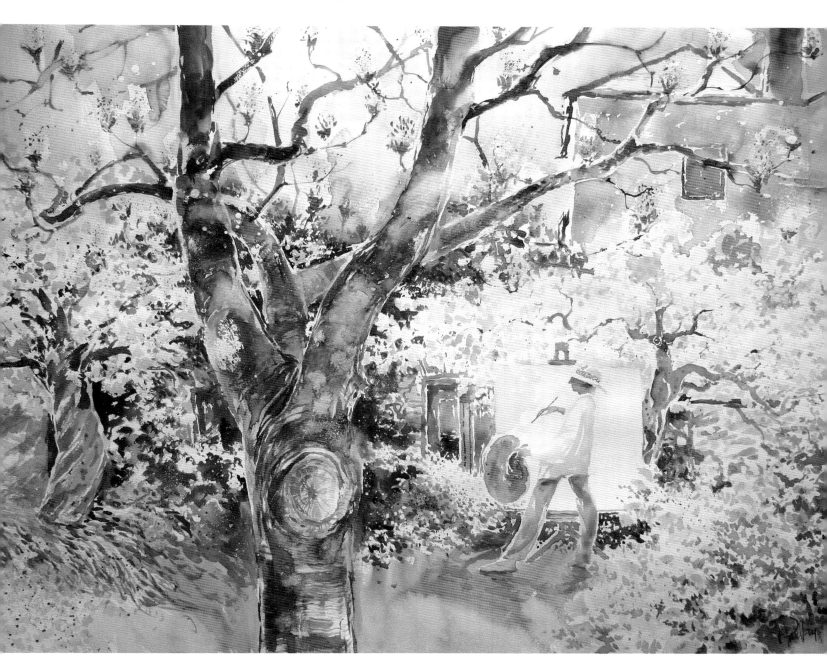

Lady with the Lamp: Demonstration

I wanted to create a picture that could reflect many moods. One that would incorporate many elements: the portrait, flowers, lamplight, candlelight and the texture of glass and brass. In technical terms this offers many challenges, which are all covered in previous chapters.

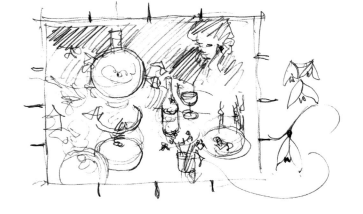

STAGE 1

As usual I started with a preliminary sketch. These are the first flowers of the year – supermarket roses with hellebores and snowdrops from the garden. The sketch shows the bare bones of the composition, plus a little drawing of a snowdrop to get my hand in.

STAGE 2

I began the painting by using a very wet technique with a lot of bleed and random effects, mostly out of control. The major control was in the masking fluid for the lamp contour, highlights on the lamp base, the snowdrops, candles and so on. Where I wanted soft highlights, I lifted them with a sponge.

STAGE 3

Next, I concentrated on the portrait. My aim was to make it recede into the background rather than being very definite. To maintain the feeling of flickering light, both from the oil lamp and the candles, I used lost-and-found edges both in the face and the glassware.

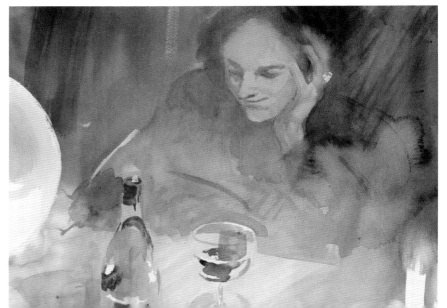

STAGE 4

I removed the masking fluid throughout and with a fine sable brush picked out details on the lamp and the flowers, starting with the snowdrops.

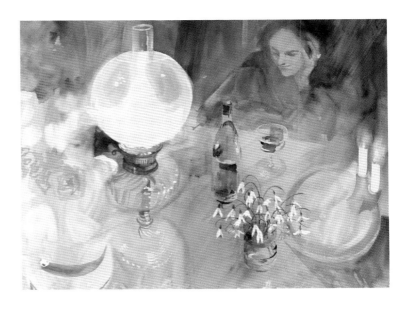

FINAL STAGE: Lady with the Lamp, 51 x 71cm (20 x 28in)

The roses and the hellebores are now painted and the lamp is finished, including the etched decoration. The final softening to the face, background and candle flame was done with a sponge.

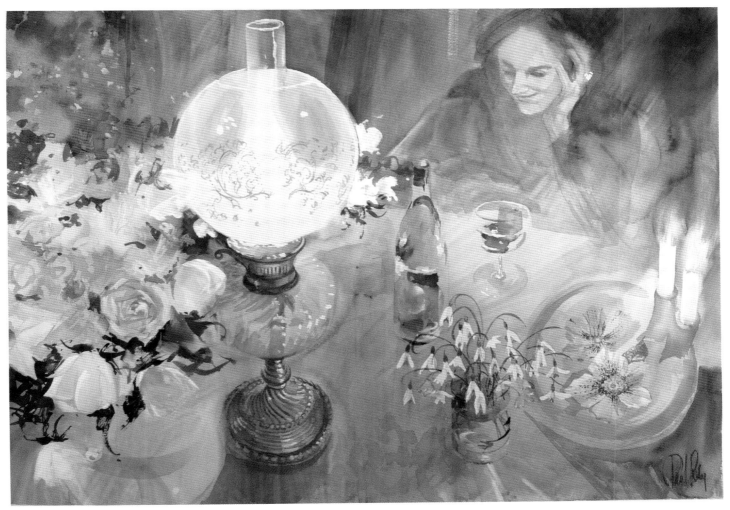

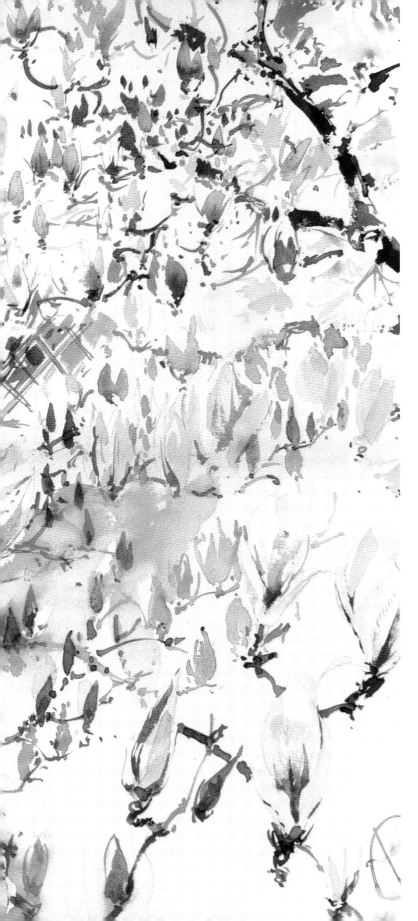

CHAPTER 8

FLOWERS IN GARDENS

Whether you have a flourishing garden of your own or not, you shouldn't have any difficulty in finding garden subjects. When it comes to painting the larger scene, many people are daunted by the profusion of plants and their variety. What is needed is a good plan and a little practice. Many gardens will have a definite feature or theme that you can exploit. Most plantings break down into zones, with particular colours, tones and textures. Once you see and understand the various sections the problem of painting them is not so taxing.

**Folly through the Magnolias,
60 x 97cm (23½ x 38in)**
I like to bring a little fantasy into the garden paintings. This folly provided an ideal subject especially seen through the springtime magnolias. The whole is a riot of blues and violets.

Different approaches

Here you can see two contrasting methods of painting in a garden. One is to look at a section of planting with several species of flowers; the other is to focus close up on two or three blooms. I enjoy both approaches as they require different skills and provide different rewards.

Birdbath in a Devon Garden, 30 x 50cm (12 x 19½in)
This cheeky birdbath bearer was ideal as a focal point.
He served to contrast wonderfully with the planting.

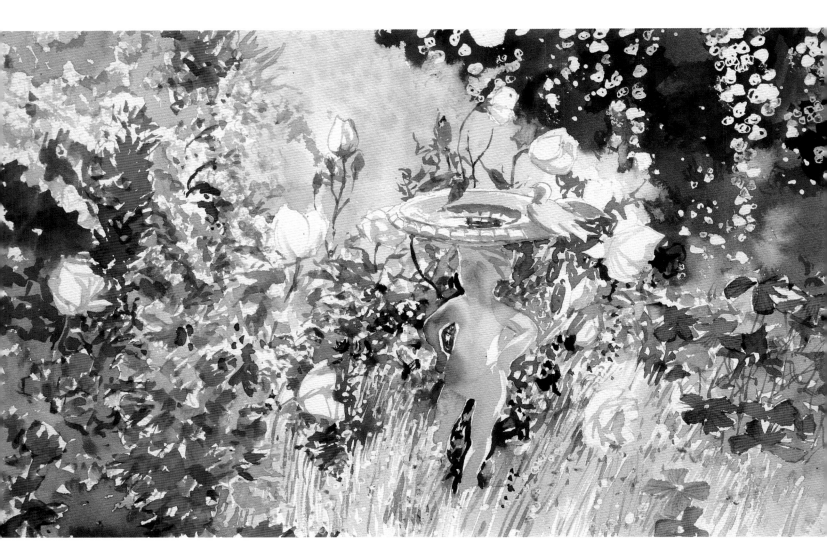

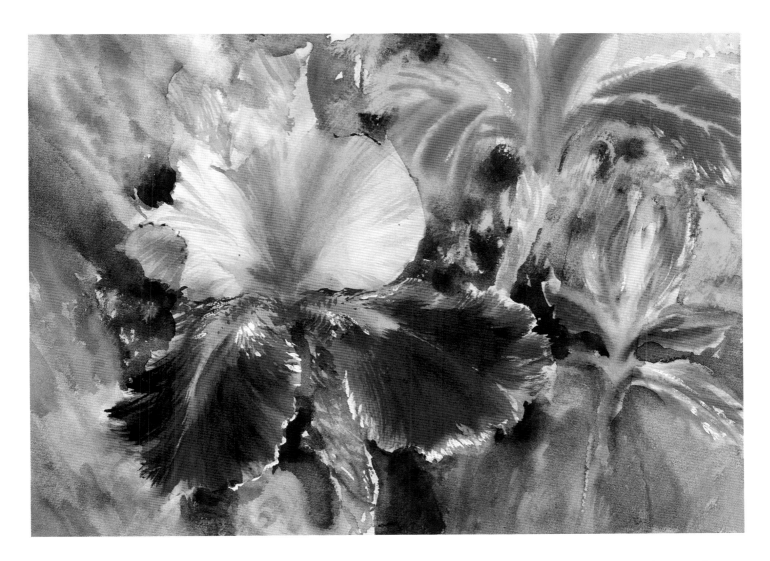

With the first method, you need to break down the flowers into zones, just as an experienced gardener does when planning a planting scheme. These zones are considered in terms of tone – mid, light and dark – then colour, depending on the flowers and their foliage, and finally texture. This varies from the big shapes of individual flowers to intermediate simple touches here and there to fine elements such as dots and lines. To anchor the whole composition, there must be a focal point.

Mauve Iris, 33 x 51cm (13 x 20in)
Here I have painted out-of-focus flowers to create depth, implying the garden beyond. Flowers can seem quite scary seen close to, and I have exaggerated some of the irises' features to illustrate this. Strong tonal contrasts add impact, together with a variety of textures.

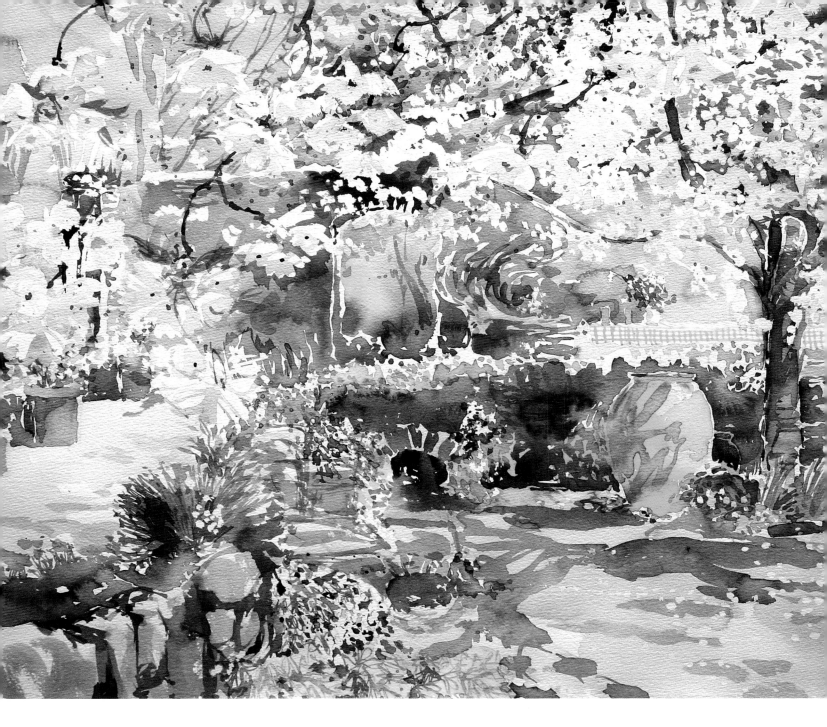

Coombe Courtyard, 56 x 76cm (22 x 30in)

After a long winter, the explosion of white and pink cherry blossom refreshes the mind and the heart. The urge to paint it is overwhelming, but there is a problem; for white flowers on white paper, special techniques are required. First, apply masking fluid immediately after drawing out the composition, then find as many different ways of negative painting the blooms with a variety of contrasting backgrounds. As much contrast as possible is the key.

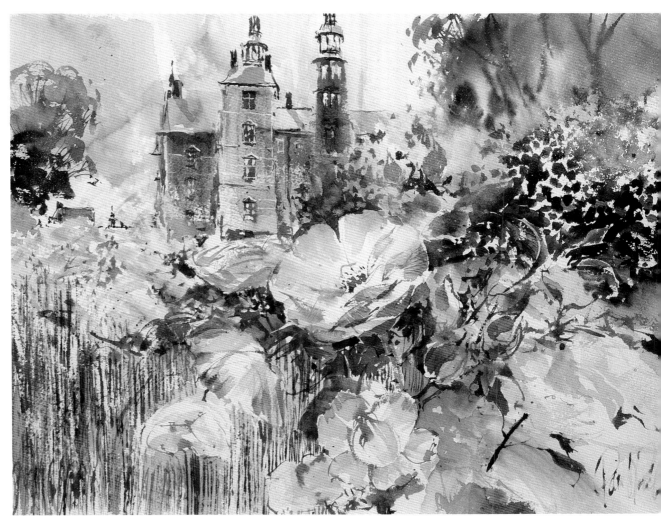

Roses, Rosenborg Palace, Copenhagen, 33 x 42cm (13 x 16½in)
This scene is not entirely true although painted 'in situ'. I had to cheat and combine
two different views. This is how you can get so much more from a location.

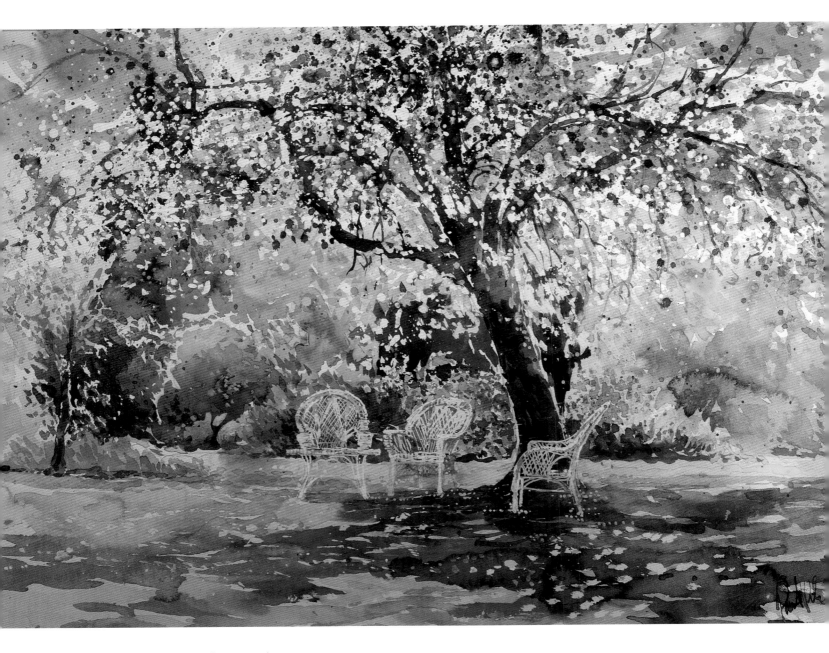

Bea's Garden, 56 x 76cm (22 x 30in)

The hardest type of garden painting to do is the 'vista' – there is so much of it that it requires careful planning, many brushes for the different sizes of flowers and leaves, negative painting and so on. It is imperative to make a large expanse of lawn interesting. I have included daisies and buttercups and striated the surface with shadows, increasing the parallels to give perspective and therefore depth.

Abbey Gardens, Tresco, 56 x 76cm (22 x 30in)

Cézanne and van Gogh were both artists who introduced powerful rhythms into their landscape paintings. If foliage, particularly grasses and long leaves, is present it gives ample opportunity to generate these rhythms. The painting here is of tropical plants which twist and turn dynamically like raging currents in water. The painting overleaf displays similar movements.

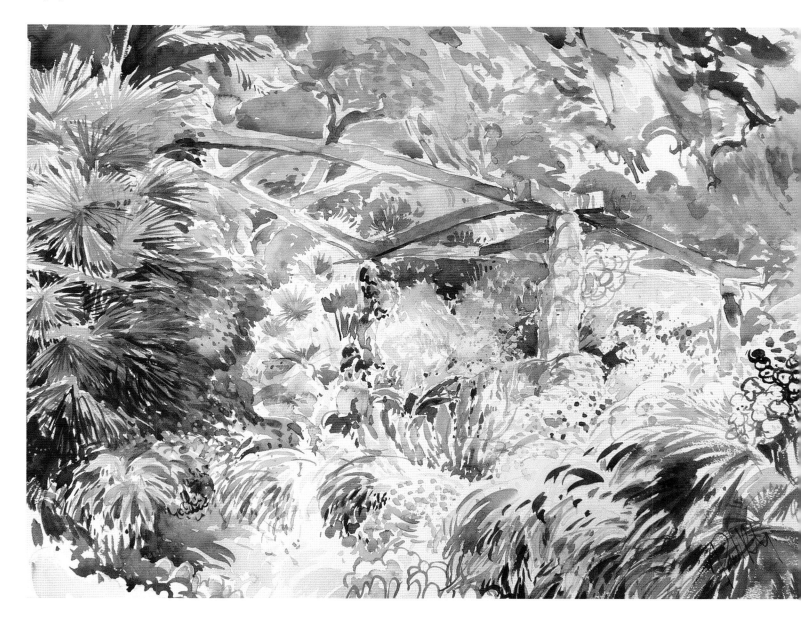

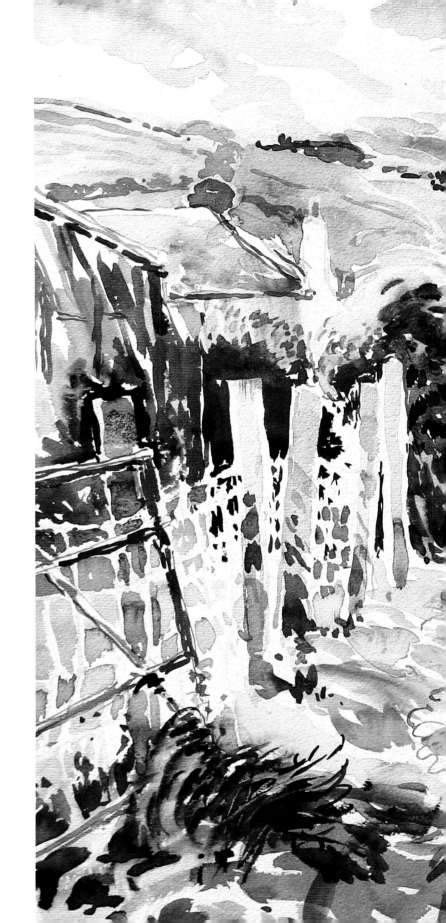

The Vegetable Garden,
56 x 76cm (22 x 30in)

For me, a vegetable garden is an endless
source of inspiration, especially if it has
been sown with flowers to stimulate
pollination. To paint this I used a large
repertoire of different brushstrokes
separated by white spaces to give them
sparkle. The strokes were directed to
give the sense of growth and motion.

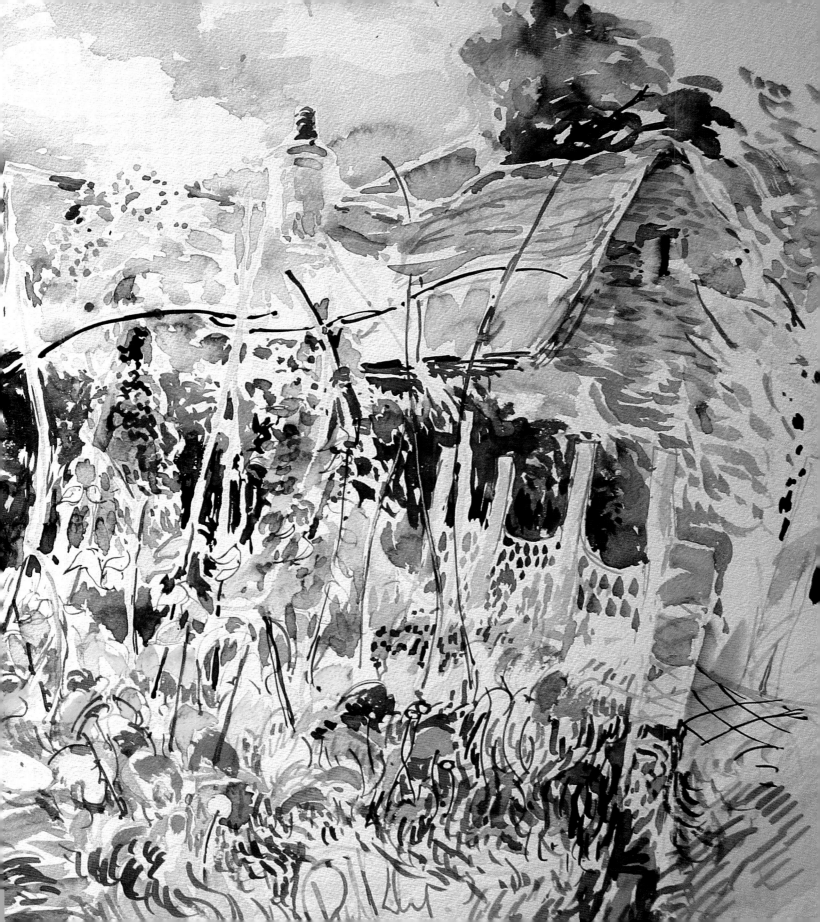

Hibiscus: Demonstration

This is an example of a close-up image in a tropical garden. The colour of the hibiscus is what attracted me, together with the size of the bloom. I wanted a painting that was striking and powerful.

STAGE 1

I began the painting by wetting the surface of the paper and applying the colour in an explosive manner. To achieve this, use the colour nearly full strength applied with a large brush (as described in stage 2) on to an under wash of phthalo blue. I have also wiped out some spaces so that I can add fuchsias at a later date.

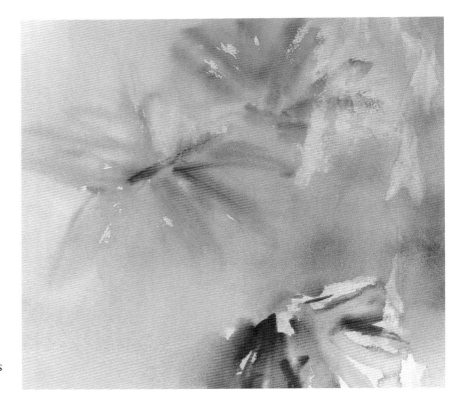

STAGE 2

To add more detail to the hibiscus I used a large oriental brush with hairs that easily separate to give striated marks. These simulate the folds characteristic of the hibiscus flower. The other brush I turned to for this effect was the one-stroke sable flat, used on edge.

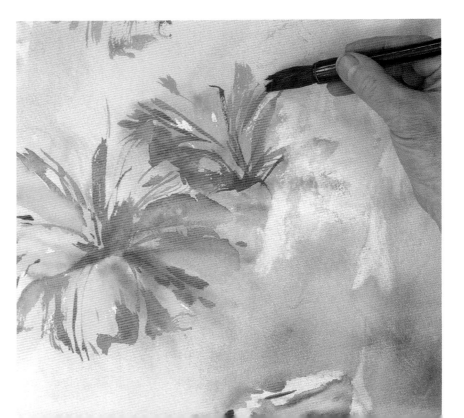

STAGE 3

It was now time to indicate the background plus the other flowers. These are hanging fuchsias with violet bodies, their delicate shapes contrasting strongly with the flamboyance of the hibiscus. The foliage is treated in a simple abstract manner so as not to compete with the flowers.

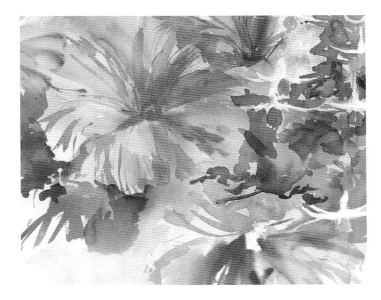

FINAL STAGE: Hibiscus, 28 x 40cm (11 x 15¾in)

These big blousy blooms need final details to finish – for example, the large anthers have been lifted with a stiff brush and water, the pollen buds have been picked out with a scalpel and tinted yellow.

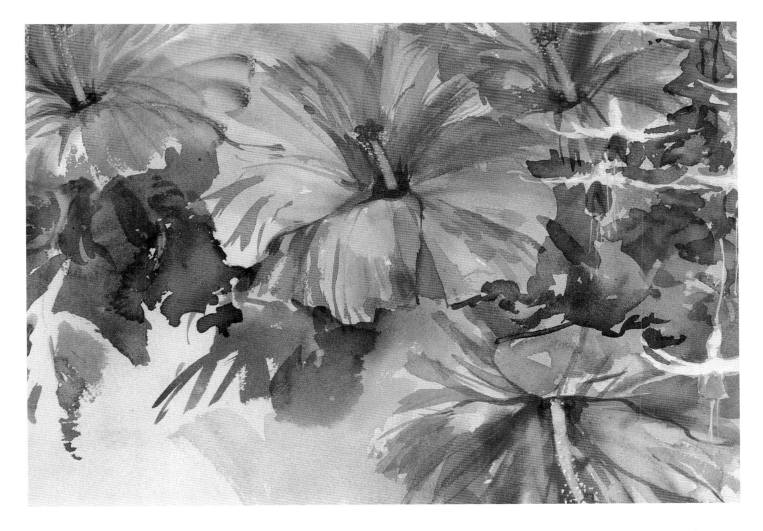

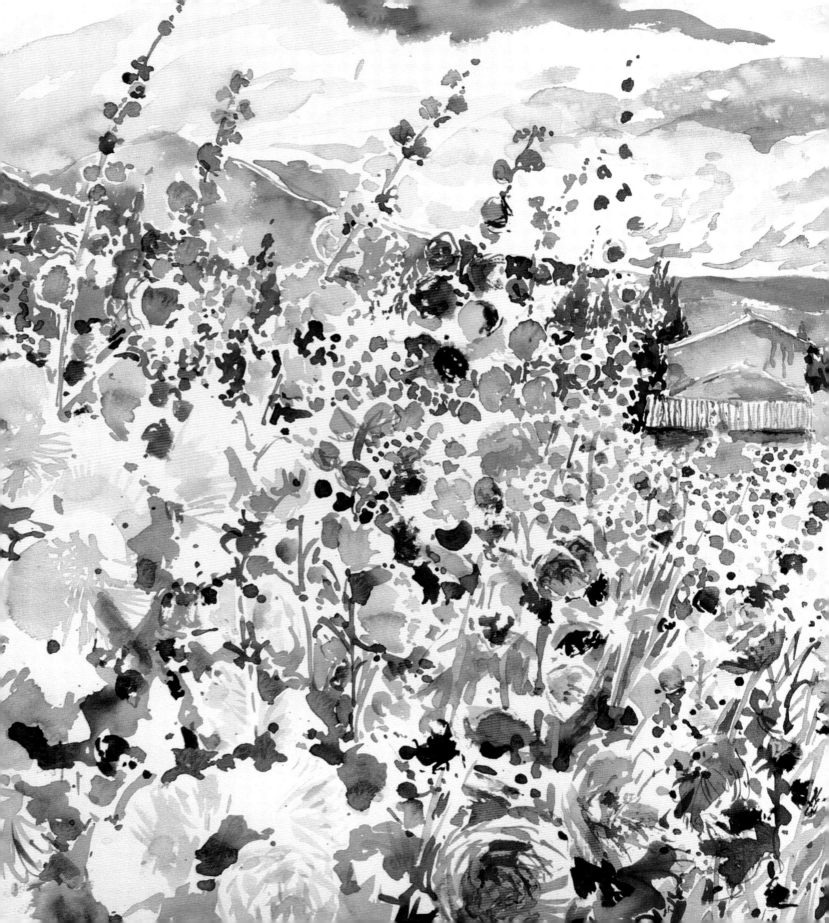

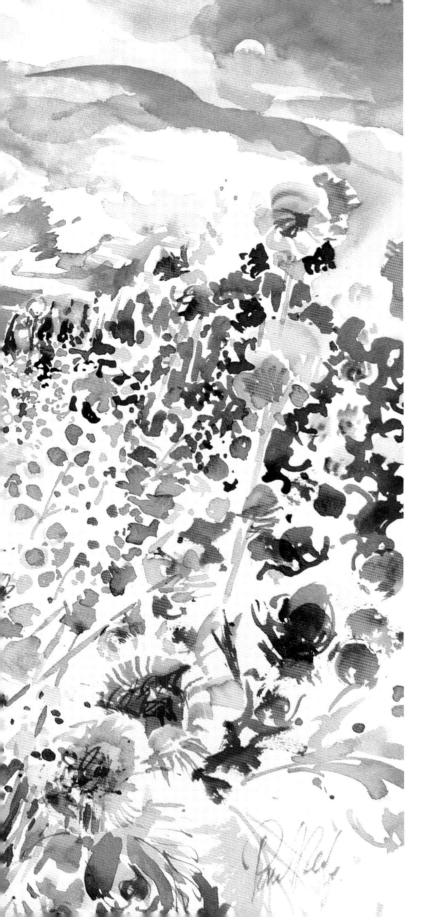

CHAPTER 9

FLOWERS IN THE LANDSCAPE

There are many types of flowers that populate our local landscapes and these are a source of joy to painters – wild flowers in meadows, fruit-tree blossom and wild roses in hedgerows among them. In subtropical climates more exotic plants thrive and you may be lucky enough to encounter orchids in the wild, or lakes and ponds with giant rafts of water lilies. Whenever I go abroad I look for flowers that have colonized the landscape and some of my finds have been a delightful surprise.

French Hollyhocks, 57 x 76cm (22½ x 30in)
I find it hard to think of anything nicer. Buried in a field full of flowers with wine, bread and pâté in France. But then to work! Look for patterns that swamp the distant farmhouse.

Wild roses and orange blossom

In the wild, flowers compete for space against vigorous weeds such as nettles. Some flowers are supremely successful, one in particular being the rose.

When you look at its structure you can see how the rose is adapted for its task: those thorns, those stout branches and those magnificent blooms that attract pollinators. When I paint them I am conscious of their vigour and passion. One of the pleasures of painting tree blossom is that while I work I am constantly aware of its contribution to nature by the way the entire tree hums with the sound of bees.

Wild White Roses,
57 x 76cm (22½ x 30in)

I was attracted to the jagged shapes of the roses with the in-between bits of the leaves, stems and other flowers creating a chaotic jungle of colours and textures.

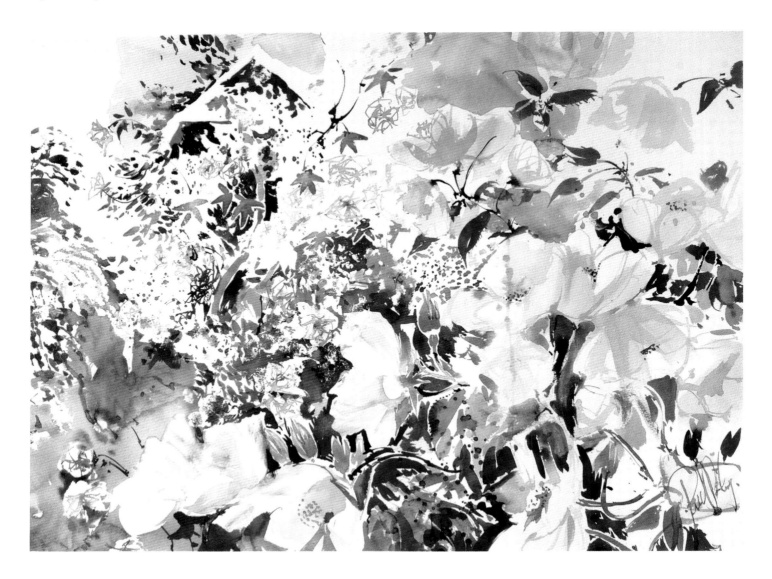

**Bees in the Orange Blossom,
57 x 76cm (22½ x 30in)**

I have used a 'U'-shaped composition to embrace the view beyond. The oranges were able to sing against the complementary blue of the sky, the yellows with the violets.

**Yellow Roses,
57 x 76cm (22½ x 30in)**

When painting *en plein air* flowers don't arrange themselves. You need to take sections from various parts of the garden to form a composition. Hence the roses were placed towards the centre with other smaller plants rotating around.

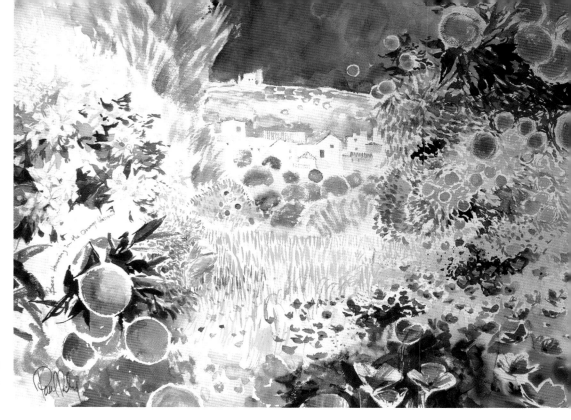

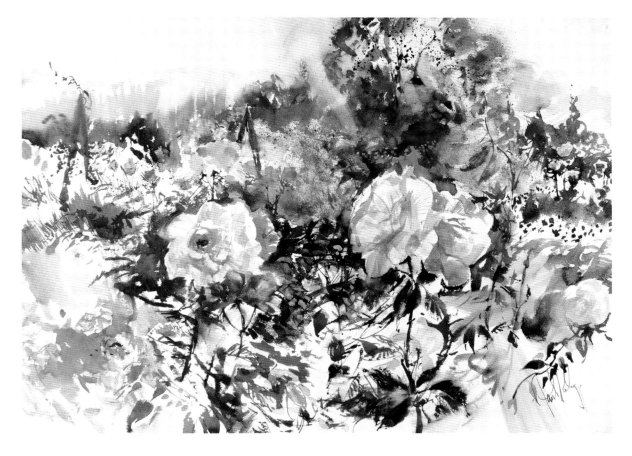

Water lilies

Water lilies feature large in my oeuvre of favourite subjects. One can see why they were such an inspiration to Monet. The subject supplies everything – reflections, shadows, depths, full leaf shapes and on occasion even fish, glimpsed ghost-like under the plants.

To paint the water successfully you need to avoid dirty brown colours and aim for reflections from trees, the sky and even the lily blooms. Water attracts all kinds of creatures, birds and insects. Incorporating these into a composition adds interest. For insects I refer to specialist books on the subject and make studies. Butterflies can be a wonderful addition.

Lily Pond, 22 x 32cm (8¾ x 12½in)
Having masked out the lily pads and blooms with masking fluid, the water was painted in vertical strokes.

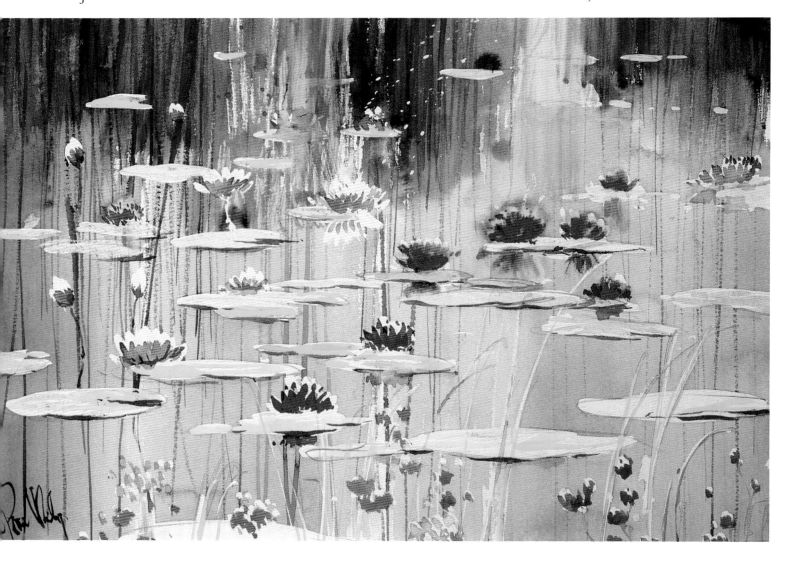

Water Lily and Goldfish, 22 x 32cm (8¾ x 12½in)
Here the goldfish were 'wiped' in using a soft, moist sponge dipped in cadmium red and yellow. This was done while the underwash of blue and green was still slightly damp. Details in the fish and lilies were added when all was dry.

Water Lilies and Dragonfly,
33 x 51cm (13 x 20in)
I wanted to add a dragonfly amid all the chaos of colour and pattern so I put it in the centre where it would be noticed.

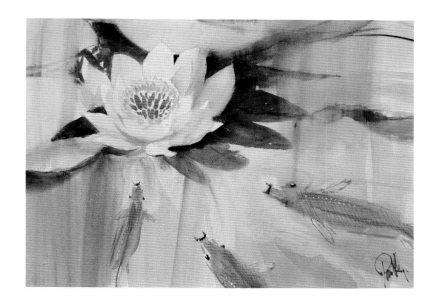

Water Lilies, 33 x 51cm (13 x 20in)

Using oils, Monet was able to evoke a sun-soaked feeling that permeated his images of lilies. Softening of edges and using vivid colours help to do this. In watercolour it is possible to achieve similar results using techniques involving sponging, wet-into-wet and an intense use of colours at full strength as shown here.

Magnolia grandiflora: Demonstration

I seated myself under a magnolia tree with the light dappling the paper – one of the joys of working outside. Magnolia is an ancient genus, pollinated by beetles rather than bees. When the trees are in flower the effect is stupendous, so when I made this painting, conveying that to the viewer was at the forefront of my mind.

STAGE 1

After completing my preparation sketch and deciding on my palette colours I used my traceur to briskly draw in the basic composition, using a violet-blue mixed from phthalo blue and quinacridone red.

STAGE 2

A large amount of negative painting was required in this image. I put in as many of the flowers as possible, otherwise the entire picture would be swamped in green. The flowers were painted using the mix as above, plus tiny touches of opera pink alternating with small touches of cadmium red. I started to introduce the green, charged with raw sienna. Much of the soft blush of colour on the tepals (the sepals on the outside and petals on the inside of the flower, which look pretty much identical) was wiped in with a sponge.

STAGE 3

The magnolia branches had enormous character and I showed them warts and all. I painted them using a broad oriental goat-hair brush in a mixture of raw sienna and green. I then dropped in raw umber while they were wet then added lots of burnt sienna when they were dry.

FINAL STAGE: *Magnolia grandiflora,* 51 x 71cm (20 x 28in)

To complete the image I added the blue of the sky, revealing the white of the petals. To the top left the blue is flicked among the flowers to create sparkle.

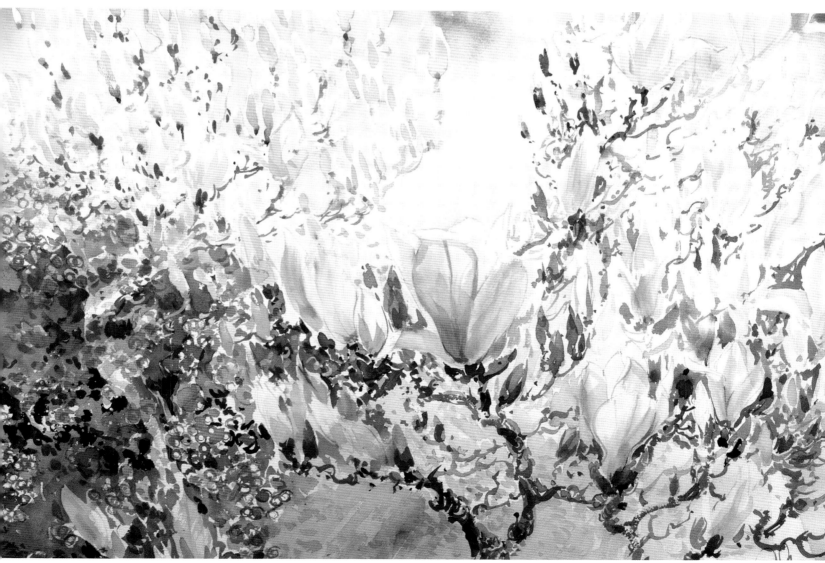

En plein air

For me, painting outside is what flower painting is all about. Hot sun, insects and inquisitive onlookers will not put me off. It is the way nature teaches you and puts you in touch with the mystery and magic of the life around you.

Like a scout, the *plein-air* painter should be prepared for anything. He should also be comfortable.

Painting outside is a peak experience for me but it does take preparation. In the photograph above you can see how I have set up a minor 'studio' consisting of a low stool giving access to my paints, palette, brushes and so forth. When I am painting a very large image I position my board on the ground, but for a smaller painting I content myself with a board on my knee. Precautions with variable weather include layers of clothing to take off or put on, a hat, sunglasses, insect spray if necessary and, most important of all, drinking water to avoid dehydration.

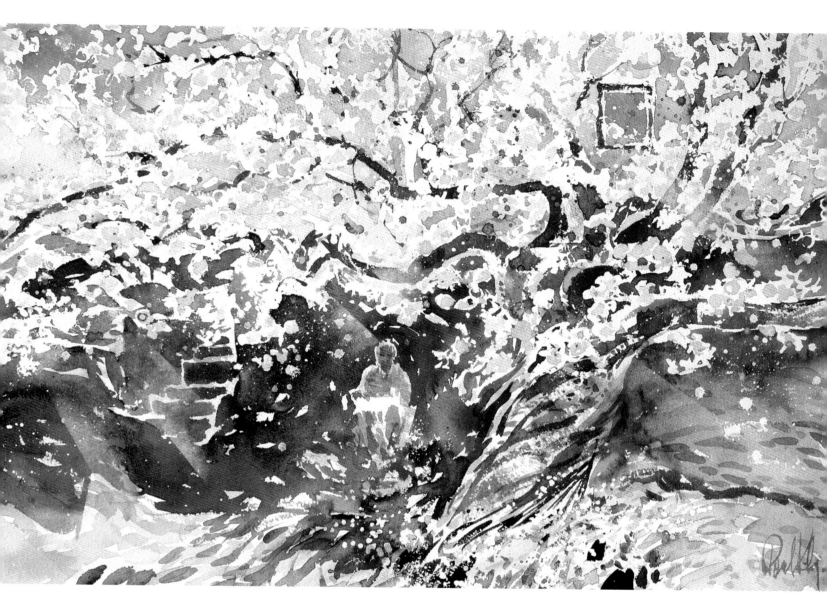

In very hot weather, fast drying of the paint can be a problem. When you are laying a wash, wet the paper two or three times and have a water spray to hand. If it rains, make sure you have enough sketch information and, if necessary, photographs to enable you to finish the painting at home – though the scene will never look as exciting as it does when you are in the presence of the real thing.

When you are painting flowers in the landscape, try to get right in among them. This will help to provide a focal point and some detail for you to describe, otherwise the flowers will just be meaningless dots.

**Under the Cherry Blossom,
32 x 49cm (12½ x 19in)**
Here is the romantic version of myself submerged in nature's swirling bounty.

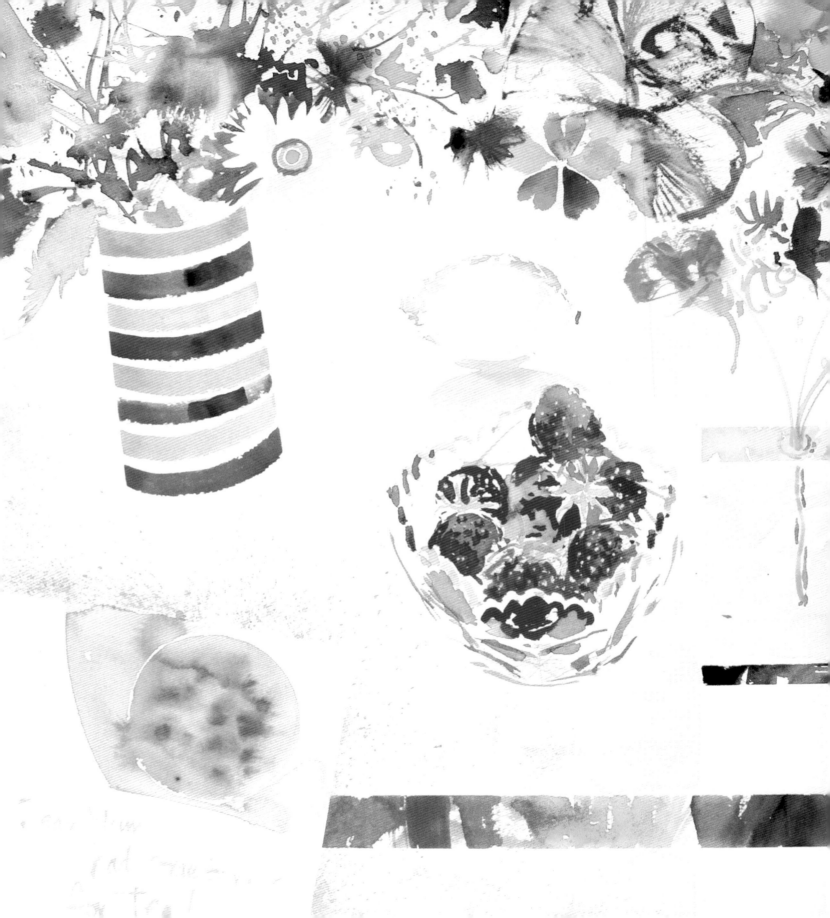

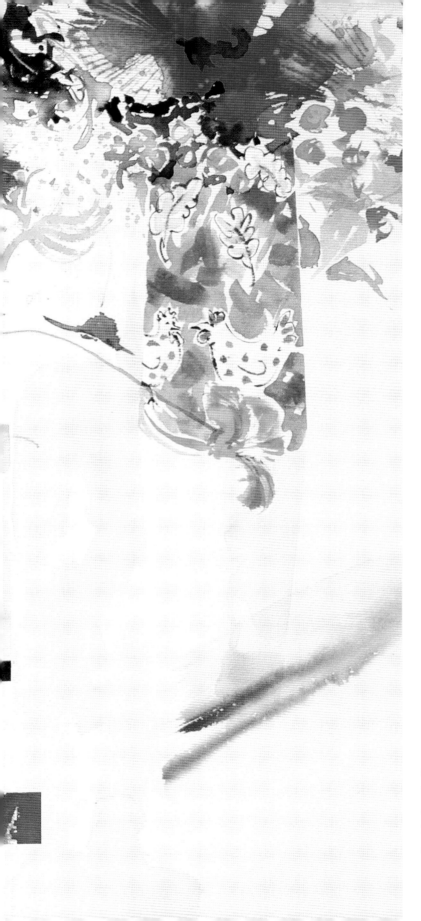

CHAPTER 10

USING YOUR IMAGINATION

It is with your imagination that you turn the mundane into the extraordinary. Some might say you either have imagination or you don't, but I believe one's imagination can be stimulated. Reading, especially poetry, and listening to all kinds of music certainly helps. Entertain flights of fantasy, remember your dreams and invent new ways of doing things, especially the application of paint. You may have, as I do, a muse who can be a source of inspiration and share your love of flowers.

Strawberries for Tea, 56 x 76cm (22 x 30in)
The choice of certain objects in a still life can suggest a story. This is a Victorian concept that I revel in. Here the strawberries evoke a June celebration surrounded by flowers of the season.

An element of love

Love, as a subject, has been a source of endless creative pursuits. The fact that flowers play a large part in the story of love makes them a great subject for painting. I often link my muse to certain flower combinations, maybe including her in the design of a ceramic dish or vase. Much of folk art uses this device and some of the examples are very beautiful. One doesn't need to be particularly serious – an element of fantasy or whimsy added to the image will increase interest. A book of love poems will provide an endless source of creative ideas.

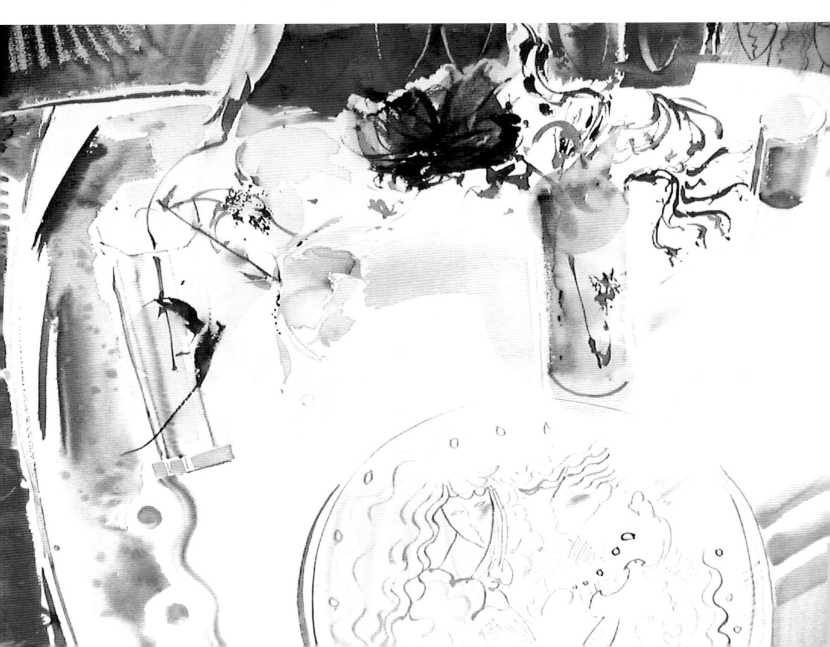

Lovers with Abstract Rose, 56 x 76cm (22 x 30in)
The poet Brian Patten describes imagination thus in
his poem 'Rauin':
'A creature you will not bother to name
but that can name itself in anything,
I push up through the stems of flowers
and step out onto lawns'.
From *Collected Love Poems*, Brian Patten.
This image endeavours to encompass this sentiment
with the lovers dematerializing into the rose.

White Muse, 56 x 76cm (22 x 30in)
Here I have painted only as much as is needed to
suggest the flowers and faces. This form of abstraction
is my way to get the feeling of just 'touching', leaving as
much as possible to the viewer's imagination. Poets do
this with their haiku style. It's fun to try the same in paint.

**Still Life with Imagination,
56 x 76cm (22 x 30in)**
Most of the objects here have been deconstructed,
their forms near symbols. The grapes have been
'printed' on using my finger dipped in the pale
green. The cut-glass effect (top right) is done by
drawing with a wax candle resist. I have tried to
see each element in a new way, painted with
invented methods.

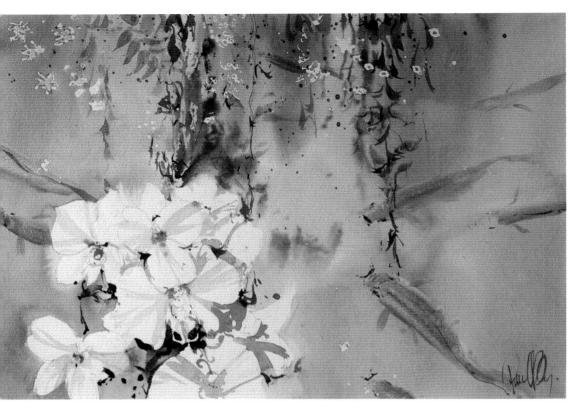

Orchids with Goldfish,
36 x 51cm (14 x 20in)

I painted this in Florida from two different locations. The orchids were in a specialist greenhouse, whereas the goldfish pond was outside in an oriental garden. I combined the two to make the whole – something that required just a little imagination.

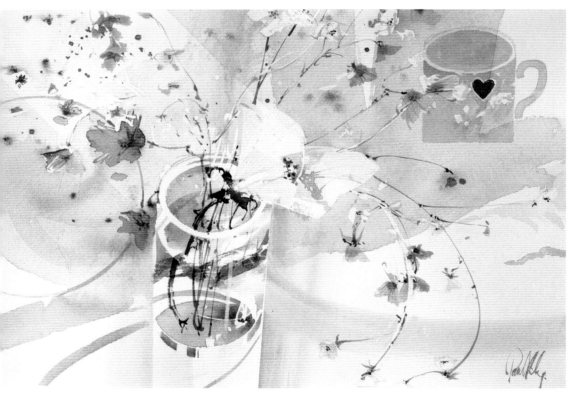

Chasing the Light,
23 x 33cm (9 x 13in)

When you are exercising your imagination it is often stimulating to cross-relate the senses – for example the smell of words or music, the colour of music or smells and so on. I also like to cross-relate brushstrokes to rhythmic sounds such as a flight of insects, or the smell of flowers. Chasing the light is about atoms, photons and that which cannot be seen.

Postcard from Denmark, 30 x 50cm (12 x 19¾in)
A useful device I employ from time to time is to imagine
sending a postcard to a friend in the form of a painting.
I extend this by way of a faux or genuine collage. These
fragments can be a distillation of your thoughts and
impressions and feelings about a place, a kind of visual diary.

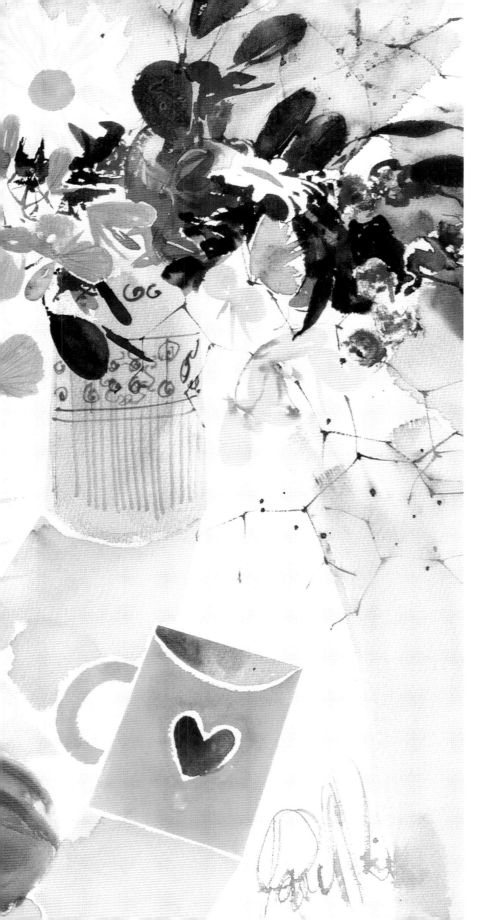

Flowers and Fantasy, 51 x 71cm (20 x 28in)
Maybe it's all a fantasy – a half-world between asleep and awake. In our world we need to dream, and in our world as painters we can make our dreams a reality. I have employed many of the techniques described in this book to execute this image. For example, the dish was drawn in paint using a compass brush; the fruit in the bowl was simply sponged in. The vase and mug were defined by masking tape and painted. The rainbow strokes were done with a Hake painted with different colours. Note the fish swim from one space to another, creating an alternative dimension.

Acknowledgements

It is an immense privilege to be asked to write a book, but as any artist/ author knows, the greater privilege is the help given by others to make it happen. I am extremely fortunate in that I have my Tina, who has so many skills, not least that of deciphering my writing. What skill I possess as an artist all starts with my mother and father, both painters. The environment in which I work, Coombe Farm Studios, is a product of our whole family and it is ideal. Added to that are the numerous students over the years who have stimulated, criticized and amused me, and gained from me, I hope. I thank them all.

I am much indebted to the following, in whose gardens I have been allowed to set up my easel: Paul and Sal, Gay and David, Jilly and Pedro, Peter and Bea, Richard and Sheila and Bridget, together with the many garden centres we have plundered for inspiration. I have been fortunate that several suppliers have generously helped in no small way to defray this artist's costs. They are St Cuthberts Mill for Saunders Waterford paper and Schmincke and Winsor & Newton for paints. Thanks also to Rosebie Morton for super sweet peas!

Thank you, Brian Patten, for graciously allowing me to quote from your book *Collected Love Poems*.

Photography is by Malin Sjoberg and Paul Riley.

Finally, my thanks to Sally Bulgin and all at *The Artist* magazine for keeping the faith, and especially those at Pavilion books: Kristy Richardson for fine-tooth editing and Cathy Gosling for her encouragement and advice.

Index